Hotel USSR

MEMOIRS OF A SOVIET 'NON-ARTIST'

OLEG ATBASHIAN

Second edition with color illustrations

ISBN-13: 978-1-7240-0332-4

Some names and identifying details have been changed to protect the privacy of individuals.

PREFACE

Most of the art in this book I created in my early twenties, while I still lived in the Soviet Union. I used oil, pastels, watercolor, gouache, ink, as well as rusty nails, cigarette ashes, matchsticks, and whatever else came in handy on my travels through Ukraine, Siberia, the Caucasus, and Central Asia.

Having no state-issued art school diploma, I was denied professional art supplies. They could only be sold to members of the Artists Union. This has a curious explanation, which goes to the root of our existence as subjects of the state.

We didn't pay taxes; our money was withheld by the state, and we received a survival minimum. The state used that money to provide us with "free" services and to subsidize many products, especially Western imports that otherwise would be unaffordable to us. But since subsidizing everything for everyone would be an economic impossibility, certain products were rationed and limited to select groups of people. The state used such rationing as a tool of control: "do as we say" or lose your privileged access. Rationing art supplies encouraged the Artists Union members to stay within defined creative boundaries, lest they be denied paint. State control of art galleries accomplished the same goal.

By default, this system of sticks and carrots made an outsider like me a non-artist without the ability to paint, exhibit, or sell my work.

Young and rebellious, I thought I could beat the system and continued to paint. My youthful enthusiasm lasted for several years, until I realized that I'd been beating my head against an impenetrable wall made of regulations that governed our existence within the state. Feeling thwarted, I gave up painting and moved on to writing, which I thought only required a pen and paper. I was wrong there too, but that story is for another day.

I now live in Florida, making digital graphics. On a recent trip to my Ukrainian hometown, I found my old creations in my parents' closet, in various stages of decay. I photographed them and later digitally restored the images on my computer. Fortunately, I no longer needed an approval from the state to exhibit them in my personal online gallery and sell the prints to anyone who wants them. See them all at *Atbashian.com.*

Restoring these pictures brought back memories of those years and all the stories behind their making. First I started to write them down as blog posts, but my notes soon began to resemble pieces of a jigsaw puzzle asking to be arranged into a bigger story. Before I knew what that story was, I spent months putting the pieces together and filling in the parts of my life where no pictures existed.

To streamline this story, I merged some characters and skipped events that weren't relevant or would be a digression. I also changed some names, so as not to embarrass the people who may still be alive.

Oleg Atbashian

1

In kindergarten they called me "the boy who can draw." I accepted this title as self-evident without being cocky; drawing defined who I was. My earliest memories were about drawing. Pictures in books seemed more important than stories. When we used to draw doodles for one another, I never discouraged others. On the contrary, watching them draw pictures for me provoked some very pleasant tingling around my heart. Years later I experienced similar tingling when I started dating.

One day on a kindergarten playground a girl of my age approached me and said that she knew how to draw a butterfly. She wanted to draw it for me. I had a pencil stub in my pocket and she had a crumpled piece of blank paper. Watching her draw squiggly lines with my pencil on her paper sent my heart

aflutter stronger than usual. This was true intimacy: trusting and vulnerable, she was exposing her inner world to me, and it made me feel happy, grateful, and protective of her. This connection between drawing and intimacy continued long into my adulthood.

In elementary school we learned to write using dip pens with metal nibs on the ends. We sat at heavy wooden desks, with scratches revealing layers of old paint. The desks were grooved with special indentations: a long and narrow one for the pen and a round one for the inkpot. In our backpacks we carried boxes with spare nibs, protective cases for the pens, and bottles of writing ink, which stained our hands, books, clothes, and backpacks with dark-blue blots.

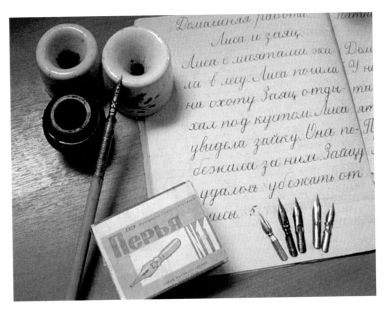

A typical writing set of a first-grader in a 1960s Soviet school: an inkpot, metal nibs, and a notebook to practice calligraphy.

Ink and nibs were still common in the late 1960s, sold cheaply at the local Cultural Goods store, although most adults had already switched to refillable fountain pens. Ballpoint pens had only begun to appear; the teachers forbade their use lest we ruin our handwriting.

We wrote our first letters in ruled calligraphy notebooks - starting with tilted lines, ovals, and squiggles, and later assembling them into letters. We filled line after line with the same letter, aiming to make them identical. My penmanship was atrocious but fun to look at because every letter came with a personality.

One time I wrote a capital "D" that looked exactly like my classroom teacher. I stared at it, trying to understand why it had that effect. None of those squiggles looked like her double-chinned face or her corpulent body. Yet all of them coming together - meeting at different angles, somewhat misshapen, each with its own direction and magnitude - they nailed her character perfectly. It was a miracle: a drawing that didn't mirror reality yet delivered a truthful portrait. This was too crazy to share with my classmates, but I held onto that notebook. When I reviewed it years later, the letter "D" still looked like our teacher. It was similar to what happened in my dreams, when I didn't know what I saw but knew who it was. All conscious attempts to recreate it on purpose failed. I thought to myself, what if all my other doodles were someone's portraits and I just hadn't met those people yet?

School to me was a clubhouse where I could enjoy drawing pictures, show them to classmates, and get their approval. Membership in this club came with

homework and classroom assignments. I got good grades if a topic seized my attention, or I would focus on drawing, if not.

All first graders automatically became members of the Little Octobrists organization, named thus in honor of the October Revolution. We wore star-shaped red pins with baby Lenin's face in the middle, and pledged to live like Lenin, who we knew to be a perfect child. That meant we had to be thorough, obedient, truthful, respectful, brave, and faithful to the cause of building communism. At the end of third grade we all became members of the Young Pioneers organization. We wore red scarves on our necks and star-shaped red pins with a

stylized profile of Lenin's bold head. We pledged our allegiance to the Communist Party, saluting it with our right hand, and chanting, "Always ready."

On April 22, 1970, when I was in third grade, the country celebrated Lenin's 100th birthday. For about two years our city had been preparing for this event by constructing a large Lenin monument on central Lenin Square. The granite for it had been extracted by prisoners at a nearby quarry, and then sculpted on location by a team of experts from the Leningrad Monument Sculpture Factory, the only organization authorized to build Lenin monuments.

Third graders from the entire city were brought to Lenin Square for the unveiling. It was followed by a massive official ceremony of their initiation into the Young Pioneers. Our teachers excitedly told us that we were lucky and especially honored to become Young Pioneers during an anniversary that would only occur once every 100 years. The polished granite steps leading to the monument had been covered with piles of flowers. Each one of us also brought a bouquet of flowers, and we laid them on top of the existing pile. A woman with an extremely loud voice tied a red scarf around my neck and I became a Young Pioneer.

Soon afterwards a classmate drew a stylized picture of Lenin on a sheet of paper by copying it from his Young Pioneer pin. The face came out crooked, but he had done his best and was proudly showing it to everyone. The teacher saw it and shook her head. "You are not authorized to draw Lenin," she told him kindly. "There are special artists to whom the Party and the state grant this honor, and they earn this exclusive privilege by being the best of the best. Everyone else should abstain from it lest there be consequences." My classmate's face turned

red; he was an exemplary student and this episode put him to shame. It had never occurred to me that anyone could draw communist symbols for their own enjoyment.

The same teacher told us how lucky we were because our generation would get to live in a free communist society. Our government had promised us it would build communism by the time we would reach adulthood. We would be free to do anything we liked, live anywhere we liked, do any work we liked, and have all the things we liked without paying for them. Money would disappear because free work by free people would bring about unthinkable abundance. What was there not to like? To me it sounded like a never-ending childhood, only better. The projected date for this miracle was 1980, ten years into the future. For us, ten-year-olds, that seemed like an eternity and we wished it could happen sooner. I imagined myself being a free artist, going out with friends to see free movies anytime I wanted, and eating lots of ice cream bars at the corner kiosk without having to pay for them. Thinking about it, I drew a picture of angels flying in paradise, with God's bearded face peeking through the clouds.

At that point, the teacher snuck up on me from behind and grabbed my unfinished drawing. "Religious propaganda is unworthy of future citizens of communism," she stated. "There will be consequences, for you and your parents."

"Communism means I am free to draw anything I want, you said it yourself. Give it back!" I demanded.

"We haven't reached communism yet, this is socialism, and you have to do what you're told." She started to walk away.

I ran after the teacher and tried to force the paper out of her fingers. She raised her hand, but I kept pulling on her sweater until her arm was low enough for me to get hold of my picture. I returned to my desk, smoothed out the paper, and continued to draw. This incident was a massive embarrassment for my mother who taught English at the same school.

Seeing my obsession, my parents decided to send me to art school. The closest one was a boarding school in Kiev, about two hundred miles away. Its program began at the fifth grade level and only children of that age were accepted. The entrance exams included drawing and painting. With applicants from all of Ukraine, the competition was tough. I knew nothing about painting but I still was in fourth grade and had a year to prepare. My family couldn't afford a private art tutor, but my mother knew a local artist whose daughter went to our school and was failing in English. My mother bartered a deal whereby she would tutor the artist's daughter in English, and he would prepare me for art school.

He lived and worked in the House of Artists, which put me in awe. The first floor had an art gallery with an arts supply store. The next three floors housed families of state-accredited artists. The fifth-floor penthouse with large windows and extra tall ceilings had shared art studios. Built in a prime downtown location a short walking distance from Lenin Square, the building exemplified the state's appreciation for the arts. I expected to come out of its studios an accomplished artist.

My tutor specialized in socialist realism. With large heavy strokes, he painted happy industrial workers, festive collective farmers, wise Party

Oleg Atbashian

leaders, and patriotic Red Army heroes. My eyes darted over his work, unable to find a spot worthy of lingering for more than five seconds. I soon found out that all the other artists in these wonderful studios specialized in socialist realism: their style was indistinguishable from that of my tutor.

He showed me my place by the exit door and set me up with an easel and a small stool. Then he placed a white plaster ball with a cone on a wooden chair in front of me and told me to start drawing. He never explained why nor showed me how it was done. That pretty much covered the rest of our weekly lessons throughout the year. Sometimes the shapes on the chair changed, and sometimes I used watercolor instead of pencil. What never changed was my lack of a clue of what I was doing and why. It made me, an eleven-year-old, feel stupid.

We shared the studio with a younger painter, who for many weeks stewed over the same eight-foot-tall portrait of Karl Marx commissioned by a Party organization for their hallway. Marx's face was recognizable, but the left arm looked as if it belonged to another person. The poor fellow kept repainting it over and over, at different angles and positions, but with the same comical result.

My tutor was in the middle of an even larger painting about heroism of the Soviet people in the Great Patriotic War. The heroic men and women were sitting in a one-horse sleigh and shooting their Kalashnikov rifles at some dark shapes representing the evil Nazis. There was a lot of snow, dirt, and blood on the canvas, and the unmistakable smell of alcohol on my tutor's breath. The heroic stern faces in the painting were being recycled from the portraits of distinguished milkmaids and award-

winning tractor mechanics he had painted earlier for a Party organization at a large farming complex.

Any exchange of comments between the two artists involved intense cussing. The most polite and frequently used word was "degenerate." I'd been aware that adults would sometimes say bad words when angry, but never had I heard people cuss so casually while gossiping about their neighbors and fellow artists, many of whom, it would seem, were rotten degenerates. By the end of the year, I still knew nothing about art, but I had learned a lot about the unsavory lifestyle of state-sponsored artists. If someone were to ask me about my art classes, I would describe them as time wasted on meaningless drawings so that in the future I could become one of the drunken degenerates.

Even though I'd learned nothing, my parents still brought me to Kiev for the exams. Most of the other applicants I met had come from artistic families; they used professional jargon and spoke of color theory. We all sat in a large room, painting an arrangement of dishes and pots on top of a blue tablecloth. Compared to my neighbors' work, I knew my picture was roadkill.

A month later the mailman received a large envelope with a letter of rejection; paper-clipped to it was my artistic disaster that I'd hoped nobody would see. My parents were disappointed, but I was relieved. I didn't want to grow up like my art tutor and channel my art into socialist realism. The idea of a being a free artist as I imagined it was a myth. Artists had to suck up to the state and to the Communist Party; those were the only art patrons around. Common folks like my parents had no money for art; they couldn't even afford a decent art

tutor. The state withheld their money and gave it to the degenerates at the House of Artists.

I still loved drawing. To me it was like breathing, and who thinks of breathing as a career?

2

As a teenager, my interest shifted towards fantasy drawings. Stories from Greek history and mythology challenged my imagination. For example, Athena was born out of Zeus's head. It happened after Zeus swallowed her pregnant mother, the goddess of crafty thought, because he feared that their offspring would outsmart him and take over the world. Zeus developed a terrible headache and asked the smith god, Hephaistos, to crack open his skull with an axe. The smith god obliged and Athena stepped out of the crack, fully-grown and wearing battle armor.

Of course, such scenarios only happened in a metaphysical world that existed parallel to ours, was more unstable and fluid than ours, and mirrored ours only metaphorically. The parallel reality of gods and titans was one swirling, endless cataclysm of creation, the proto-world giving birth to concepts, ideas, and dominant archetypes. Their reflections populated our physical world in the form of discernible objects, or natural laws, or art.

The language of mortals couldn't describe the birth of a goddess, so its reflection in our physical world became a down-to-earth story about a headache, cannibalism, cracking skulls with an axe, and the birth of a fully-grown and clothed adult out of a male parent's head. Greek myths lacked any apparent moral. If there was one here, it seemed to

be that some things could not be avoided, and if you tried to conceal them, they would come out through a crack in your skull.

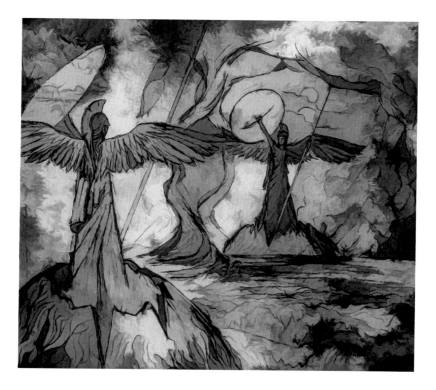

Reading heaps of science fiction stories in my teen years, I also began to make up my own imaginary worlds.

The first one was *The Planet of Thinking Crystals: an Electrical Civilization*. Its angular shapes may have looked like an abstract painting, but they were a living forest of colorful thinking crystals. Their thinking, however, was so rigid, simplistic, and abstract that it made any dialog between our civilizations excruciatingly boring and largely pointless. Though of no practical use to humans, this planet was a feast for the eye and a popular destination for alien nature photographers. Large glossy prints of its landscapes

graced Earth's corporate offices, outcompeting decorative abstractions by human artists.

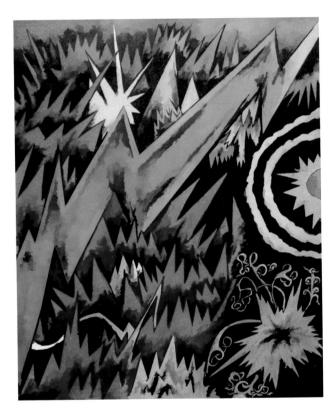

There was also a *Self-Eating Planet* that I envisioned in biology class while the teacher described the digestive system. I imagined alien life as a single organism covering the entire planet. Because every organism must eat and generate waste, the planet functioned as an enormous inside-out stomach. Its plant-like external tentacles absorbed sunlight and nutrition from the air. Then they broke off and fell through the cracks inside the stomach to be dissolved and consumed. Since all feeding occurred locally, no central cardiovascular system or a single heart existed to pump nutrients through its colossal body, an impossible task on this

scale. The absence of central organs made sure this organism couldn't be killed with a single blow. The pancake-shaped waste flew out of its mouth-like orifices to form the brownish clouds above. You didn't want to be caught outside when it rained.

How could such an organism evolve when evolution requires individuals to compete and survivors to procreate? Most likely it had emerged alongside other species but had more luck expanding to other territories, until it engulfed the entire planet. Any archaeological excavation to prove this hypothesis would be meaningless, given that the planetary stomach had already consumed and digested every organic molecule beneath it.

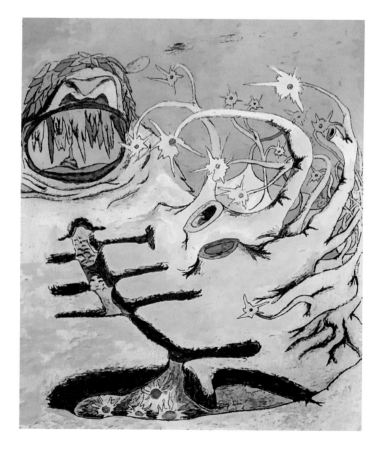

Then there was a *Planet of the Living Clouds.* It was inhabited by ball-like creatures that flew through the air in straight formations, mountainous blobs that secreted a corrosive substance from their open lungs, and gigantic intestine-shaped living clouds that covered most of the sky. Though this planet's atmosphere was toxic to humans, we still visited it to build pipelines and refineries. After some processing, its corrosive mixture of biological waste was a perfect source material for our home mini-reactors that churned out things on demand, from clothes to tools to home decor, based on fully customizable software templates. It made mass production of consumer goods on Earth obsolete.

A combination of science fiction and history books produced this horror fantasy, a nightmarish nomadic invader bringing destruction and death to civilizations of peaceful builders and farmers.

And, of course, there was a Planet of Erotic Dreams, a teenage fantasy landscape influenced by

sci-fi novels, hormones, and my attempts to fathom the inner workings of the human mind.

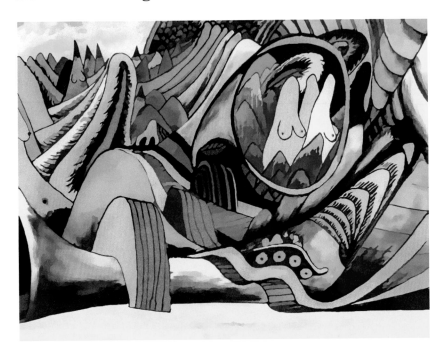

When I was sixteen, my parents covered all our rooms with wallpaper, but almost half the wall in my room remained blank. Whether they'd miscalculated the number of rolls at the store, or they just grabbed what they could before it was gone, my room had a five-foot gap running from the floor to the ceiling and from the corner to the door, right next to my bed. My mother proposed to cover it with white paper and let me fill it in with whatever fantasies my brain could turn out.

Just then a friend stopped by on his way from the black market, carrying a smuggled Elton John 1975 *Captain Fantastic* vinyl LP. I was so impressed with the elaborate album cover and the illustrated lyrics booklet that I decided to copy some of its surreal characters onto my wall. I got to work right away,

starting with the monster dog and the weeping mouse as Elton John's album was playing in the background. The rest of the composition came later.

I kept adding more objects and ideas between my other teenage pursuits over the next three or four years, until I realized that complex fantasy drawings required greater artistic skills. In the end, I left the upper part blank. What you see is a cropped version.

One rainy day years later, I drew an old house that stood on a hill leading to the Dnieper River. It reminded me of the house where I grew up and lived with my parents and my sister, and where I drew Elton John's fantasy creatures on my wall. But I'm skipping ahead of the story.

Our house was built in the 19th century for a large middle class family. Then came the revolution. The new state expropriated the house and sectioned it off into four separate apartments "for the people." No one knew what happened to the previous owners. Former servants' quarters and storage rooms across the yard were converted to six more apartments. Surrounded by a wooden fence, this former one-family property became a small "housing complex." In the 1970s, when I was growing up there, it quartered ten separate households, including three lonely old widows, three elderly couples, and four younger families with children.

We used a pump in the middle of the yard to fill our water buckets that we kept on a stool in the kitchen next to the washstand with a sink. The waste bucket underneath the sink had to be regularly taken outside and emptied into the communal outhouse. Every Sunday my parents showered in a public bathhouse three blocks away, which also had steam rooms. I took weekly baths in my grandparents' house that had a real bathtub.

The outhouse stood about a hundred feet away from the water pump. Constructed of wooden boards, it had two individual stalls, each with a hole in the floor. Two large nails on the inside wall held torn-up newspapers, the only toilet tissue we knew. When I was about twelve, a block next to ours with similar houses was leveled to build a large cultural center named "The Palace of People's Friendship." Dispossessed rats moved to our yard, some of them finding refuge in our toilet pit. I often saw them through the hole down below, feeding on kitchen waste. Their squeaking sounded much like the chirping of the birds outside. It was impossible to tell which was which.

Because our section of the house contained the original fireplace, other tenants saw us almost as aristocrats. Truth be told, the previous tenants had remade the fireplace into an uglier but more efficient coal-burning stove that heated two of our rooms, but they kept the original sculpted tiles and artistic bas-reliefs in place. I carried the coal for the stove in a bucket from a shed outside.

The coal would lay there in a pile underneath the shelves that held my mother's preserves: pickled cucumbers and sweet jams made of apricots, pears, sour cherries, and tiny paradise apples. A wooden barrier separated the pile of coal from a pile of potatoes in the corner. Every fall, my father brought several large sacks of potatoes from the collective farms where he built roads. He delivered them on his company truck and we emptied the sacks into a pile in the shed. I don't recall rats eating our supplies; our yard was also a home for half a dozen feral cats who hunted their own food. One cat made a bed of old rags in our shed and had kittens in it.

No one in our neighborhood had a telephone; those were reserved for the elites and people of certain professions. Our only modern amenities were a propane gas stove and electrical lighting. The decrepit electrical wires were insulated with knitted cotton tubes, which were held on the walls by round wooden pegs. It was as though we still lived in 1917, feeding on redistributed property but incapable of improving on it. Nobody cared what happened next because there was no "next." The revolution had frozen time.

The rent was cheap, and so were basic products and services, but miniscule salaries erased that advantage. Even if my parents had won the lottery and wanted to buy an apartment with plumbing, none was available because there was no real estate market. All housing belonged to the state and we were lucky enough to have what we had.

Our teachers kept telling us that we ought to be eternally grateful to the state and the Party for taking such good care of the children. Every time they brought it up, I would think about our house and the vanished owner's children: the same Party had kicked them off their family property and turned their childhood home into a perpetual slum. Since then, many tenants had moved in and out. The more I thought about it, the more I realized that, just like my childhood house, the entire country had been stolen from the original owners. The thieves plundered the belongings of the world they had murdered and stored the loot in a dusty shed where it remained preserved like a spoiled can of my mother's pickles.

Time had no meaning, not just in our neighborhood but in our city and in our country. In the rest of the world, life galloped forward, creating new music, new fashions, new household gadgets, and new ways of thinking. Some of it was being smuggled into our world, and that's how we knew about it. That world had no need for smuggling because everything it had was made by the people who lived in it. I wanted to be a part of that world as opposed to being preserved like a small paradise apple locked in a jar inside of a grimy shed next to the piles of coal and potatoes.

Here is a picture of my mother's preserves. I titled it *Paradise Apples, Contained: a poetic concept suspended in a prosaic container.*

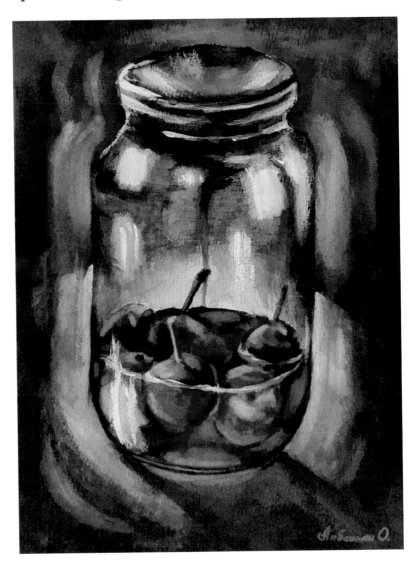

And here is my mother sometime in the late 1970s, walking across the yard, back from her trip to the mailbox. She is carrying home the *Pravda* newspaper (her mandatory subscription as a

Communist Party member) and keys: for the house, the shed, and the mailbox.

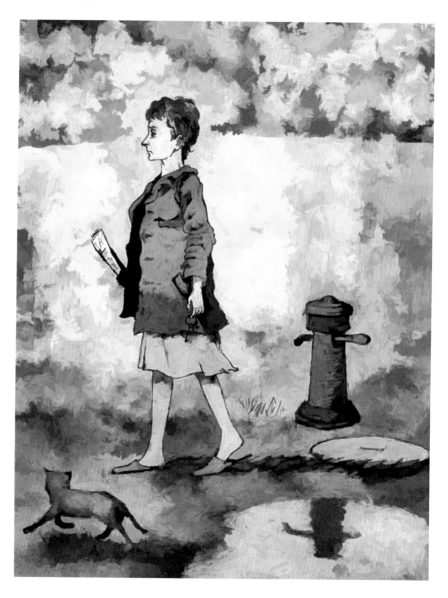

She had joined the Party with the hope that someday she could be a school principal. That position was for Party members only. She never received that promotion, but her monthly Party

dues continued for many years, as well as a mandatory annual subscription to the Party press organ, *Pravda*. She couldn't just quit her membership; no one ever left the Communist Party voluntarily. Doing so would have ruined her life and she'd be banned from teaching. Family members would have also suffered consequences. The dissolution of the Party after the failed 1991 coup made both of us very happy. I welcomed the beginning of a new era, and she welcomed the end of those dreadful Party dues.

Even with both of my parents working, we would have been in dire need if basic things hadn't been state-subsidized or free. It was understood that free things and low incomes came in one package, one being the condition of the other. With everyone else living the same way, it never occurred to me that we might be poor. Really poor people were begging for change at the farmer's market three blocks away. Officially, the poor and the beggars didn't exist. They were mostly elderly widows or war veterans without limbs, many of them alcoholics, sitting on the earth and smelling of urine. That's where I first heard the words "damaged goods" being used to describe people. When we walked past them, my mother would turn away, pretending they weren't there. Her real intent was probably to shield my impressionable mind from noticing them, as if her pretence could change the reality of what I saw.

In the evenings my mother would knit sweaters to sell, so in the summer our family could afford a train to the Black Sea and rent a room in a subtropical Crimean town for a couple of weeks.

We went there twice, the first time when I was twelve. We stayed at an old mud-brick house that could sleep five or six families of vacationers at a time. Additional families lived in a converted shed outside. The house belonged to an alcoholic military widow. At the end of WWII, the state took it away from a Crimean Tatar family and gave it to her late husband as a military reward. That was when I first learned of the ethnic cleansing organized by Stalin and Beria in 1944: our landlady referred to it as a good thing. Just like our home, this old house had been stolen and allowed to become shambles. We all shared the same one-hole outhouse and brushed our teeth in a washbasin with an unruly faucet that hissed like a snake, spitting out smelly water as if it were venom.

Early in the morning, my mother would go to the market and buy local peaches that looked like apricots but bigger and sweeter. I hadn't eaten peaches before. Fresh produce at home was mostly local and seasonal. The beach and the sea were a dream come true. Unlike our river, the salty seawater held my body afloat and I easily learned to swim. Not for a moment did I allow myself to let my new-found happiness fade. Whenever I began to take this vacation for granted, I rekindled the excitement with an easy trick: I would pinch my nose, close my eyes, and go under the waves, staying below the surface as long as I could and imagining that I was in my grandma's bathtub on a school night and still had to march home through the sleet and mud to complete the unfinished homework. Then I would leap out of the water, open my eyes, and take in the roaring foamy waves, the hot sunny beach, the magnificent rocky cliffs, and feel absolute bliss.

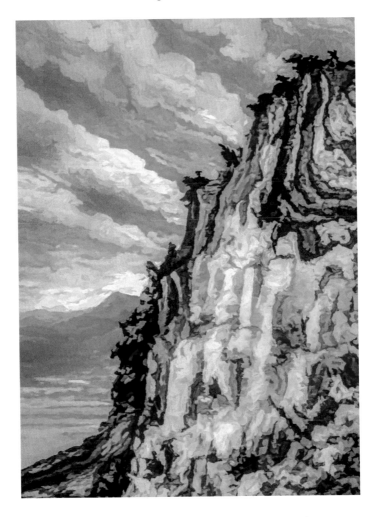

My best childhood friend had never been to the sea. He was raised by a single mother and they lived on her single income. They might have been poorer than us, but at least their one-bedroom apartment in a housing project had a real sink and toilet, and they could take baths any day of the week without leaving their home. As the society in the 1970s got slightly more prosperous and people found special ways to earn a little here and there, inequality was also increasing. That didn't bother us children; in our minds we were equals.

As teenagers, he and I used to sit on the roof of my house, watching clouds, making up stories, and eating pears straight from an old pear tree that grew beside the house. They were the sweetest pears I had ever eaten. Feral cats from the neighborhood climbed on the roof using the same tree. We didn't mind the cats, and they didn't mind us. My friend and I both liked science fiction; I drew fantasy pictures, and he made up futuristic short stories. Every time he wrote one, we would read and talk about it on the roof.

His first story was about the invention of telepathic transmission which had altered the way

humans lived in many good ways. It changed how we studied and were tested in schools, how we did our jobs, consumed our news, and communicated with friends. This gave us better alternatives to books and movies. It had also replaced telephones and made the bulk of commuting unnecessary. But there was one man who saw a dark side in all of this. He kept warning people that the government used this invention to control their thoughts and feelings, turning them into obedient robots, devoid of all individuality. He tried to disconnect himself from the mind-hive network, but state agents hacked into his brain and re-coded it, locking him in an imaginary prison inside his own mind.

I was excited that my friend wrote such a story and urged him to send it to a popular science magazine that had a section for fiction. The following day he brought another story to the roof about another great invention that changed the way humanity lived. But it was also used by the government to control people, and the man who sounded the alarm was hunted down and killed. I liked that story too, although it was very similar to the first one.

Every new story he wrote was stuck in the same loop. The inventions were different, but in the end either humanity was destroyed or the man who alerted others was killed by government agents who sought total control. It was as if my friend's imagination had been coded to spin in a circle, locked in the same virtual mind prison he had described in his first story.

His fantasies always happened in some generic, unnamed Western country, and all the characters had vaguely English names. It occurred to me that all the dystopias we read in books or saw on TV were

set outside our borders. Scary stories never happened in our society. All injustice took place either in foreign lands where none of us had ever been, or had occurred before the revolution. Another good setting for drama was the Great Patriotic War against the Nazis. Tragic war stories were encouraged and rewarded with state medals. That explained, perhaps, why every other movie we saw was about the war. Soviet authors seemed to be stuck in the same loop as my friend. Or, maybe, his brain had been coded by all their movies and books, and he instinctively tried to break out of that mind prison by writing his stories.

As with art, the only acceptable method of storytelling was socialist realism. Our teachers defined it as "the depiction of typical characters in typical situations." They officially expected us to believe that a typical Soviet citizen was a happy, conscientious, and selfless worker dedicated to building communism. The revolution had freed us of greed, exploitation, and inequality, from which all crime originated. Therefore, our society was incapable of evil.

All our fictional villains were foreign capitalists, Nazis, or their spies. Our homegrown offenders were merely lowlife cheaters, drunks, incompetent petty administrators, or degenerates who didn't appreciate how good they had it. Conflicts were often resolved when a wise Party official arrived and saved the day. It conditioned the audiences to believe that this was a typical occurrence. If someone still experienced problems, they needed a wise Party official to come and set things straight.

Thus, if my friend were to describe our country in his fictional stories about a totalitarian state that controlled people's minds and hunted down dissenters,

that would sound strange and completely improbable. There would surely have been consequences.

When the school year began, the summer ended, and so did my friend's roof stories.

My other friend lived in a privileged building for the Party elite. His parents' two-bedroom apartment had stylish imported furniture, and they owned a Zhiguli car. He wore smuggled blue jeans whose black market price equaled my parents' monthly salary. He owned the best audio equipment and an impressive collection of rock and roll tapes and vinyl records, of which he graciously allowed me to make copies. He expanded his music collection by trading records on the black market, and my small collection grew along with his.

One of my favorite tapes was the rock opera, Jesus Christ Superstar. As I copied it from my friend's LP, I also copied the entire set of lyrics from the album insert into my notebook. I'd only known occasional fragments of the Jesus story before, and now I understood what it was really about. It didn't turn me to religion, but it finally helped me to connect many dots in world culture, let alone in the history of art, which until then remained unconnected because, in our official narrative, Jesus was a non-story.

When I was fourteen, my parents bought me a cheap seven-string Russian-style guitar. My friend knew how to convert it into a six-string instrument and showed me some chords. Unlike me, he had perfect pitch. He also played the piano and tried writing songs in the style of Pink Floyd. Over the next several years, we spent countless hours at his home playing music. He and I could sing the entire Superstar score from start to finish.

His parents treated me well and seemed like fantastic people. They often held parties at their home with people in the same circles, who also seemed quite wonderful. I didn't feel jealous, but rather curious. As the Party elite, their mission was to enforce collectivist ethics of economic equality, and yet they were making exceptions for their own

families, exploiting loopholes in the system so their children could have the best life and opportunities. Sure, they acted on their parental instincts: devotion for one's children is an admirable human virtue. They would have been cold-hearted parents if they hadn't. What bothered me was an apparent conflict between their parental love and the principles of equality and social justice on which our people's state was based. I knew our principles to be humanistic and moral. But how could anything be humanistic and moral if it criminalized human nature and punished virtue?

That was a scary discovery. How could we ever achieve equality when some families were more loving than others, and their unequal love made for unequal children? But even if equal love could somehow be enforced, children would still be unequal because their families had different means and abilities. No amount of love could help my friend's single mother to pay for a Black Sea vacation or to move to a privileged building. And since equal love didn't guarantee equal care, full equality could only exist where there was no love and no care at all, the opposite of goodness. But the opposite of goodness was evil. Had we switched the definitions?

Could our state be founded on evil redefined as common good? Our teachers were telling us that capitalism was evil and riddled with contradictions caused by inequality, whereas our society was good and had no contradictions because all people were equal. But we weren't equal at all; if we were, that would contradict human nature, which compelled all loving parents to give the best to their children.

I knew that our country had shameful secrets in its past and awful policies in its present, but like everyone else, I blamed the corrupt and incompetent bureaucrats who'd weaseled their way to the top and bastardized a great idea. As teenagers our common belief was that if young, smart, and honest folks like us were in charge, life would change for the better, because overall, our societal goals were noble and our foundation of equality and justice was virtuous. But what if our foundation was evil and our goals were delusional? Could that be the reason why honest and competent people never made it to the top?

In the communist future, we were told, material inequality was supposed to wither away due to the abundance of goods and services, which everyone would use conscientiously according to their needs. The institution of family would also wither away, freeing us from the burden of caring for our offspring. Professional educators could raise them better, without the corrupting influence of their parents. With everyone focused front and center on the future abundance and comfort, losing the institution of family seemed like a distant blur on the horizon. Back in 1917, Lenin and other creators of our state expected that collective ownership of the factories would motivate the workers to be more innovative and industrious, spurring exponential technological progress and economic growth. But the exact opposite of what they prophesied occurred. Decade after decade, the promised abundance still receded like a distant blur on the horizon, and the family remained solidly front and center, conflicting with social justice and corrupting the distribution of goods and services.

If a Western businessman shared his wealth and privilege with his family, it was his personal matter. If a Soviet official did the same, it was crime and corruption because he could only do that by stealing from the people's state that owned all the wealth and distributed all the privileges. To make us equal, the state regulated our existence in a way that left very few things to our personal discretion. We owed our lives to the state and had to abide by its collectivist rules. But with so many rules, not a day went by without breaking at least one or two, because we were human beings, not unfeeling robots.

Out of seemingly good intentions, communists had built an impossible system where a fight against crime and corruption became a fight against human nature. It was an uphill battle against people's natural instincts to be free, pursue happiness, and care about their children. What used to be virtues had become vices that corroded our collectivist state from within. The only way out of this deadlock was to abandon our goals of economic equality and to start living in harmony with human values, in a normal and free society, accepting unequal incomes as a small price to pay for the freedom to live as human beings.

I thought I'd unearthed a terrible secret. I wrote it down in a thick notebook that later became my journal. It wasn't a diary; my daily existence was too insignificant. What I wrote there were occasional thoughts, funny colloquial phrases, or imaginary dialogs. When I reached the last page, the notebook went in a drawer and I started a new one.

I don't know where those notebooks are now, but if someone were to read them today, they might falsely conclude that I was a thoughtful young man.

That would be a mistake because I was as much of a goofball as the next teenager, wasting time on harebrained endeavors and committing occasional thoughts to the notebook mostly in order to free my head for my next escapade. I still can recall some of the thoughts I wrote down on its pages.

No information blockade or travel restrictions could hide the obvious: the West was better at creating abundance than we were. Equally damaged by war, West Germany had long ago outstripped East Germany, which copied our model. South Korea outstripped North Korea, and Taiwan outstripped China. Cuba sounded like a mythical island off the American coast, but their only achievements seemed to be the harsh cigarettes stuffed with cigar tobacco that were sold in our kiosks. The pretense that our model was better couldn't make it so. We acted like the people in an old fable who kept praising the emperor's dress long after they realized he was naked. Why did we do it? Why did we pretend we were still building communism when most people had stopped believing in it? Why did we live isolated from the rest of the world? Why did we continue to sacrifice our wellbeing to a myth?

The only answer I saw was this: our elites had grown too comfortable in their positions. They knew their methods were failing, but the scheme they were running had kept their families above the squalor, and it served them too well to abandon it voluntarily. Rather than building communism, they tried to delay a collapse of this system until they retired, preserving a regime of enforced inequality in the service of a myth of total equality.

It was better than Stalinism by any measure; gradually recovering from the terror of gulags, our

society was becoming more humane. With each passing year, the country drifted further away from the archaic doctrine of communism, and that drift was splitting our society apart. The doctrine fanatics developed hatred of modernity and contempt for the inferior humans who were no match for their superior ideology. Those who accepted modernity developed a skeptical view of the doctrine. The country languished in a stagnant, perpetual compromise.

By the end of high school I no longer believed in the promised advent of communism, which I considered to be amalgam of science fiction, mythology, and fairy tales. Neither did I believe in the wonderful future I'd imagined while reading science fiction, certainly not in our country. Nothing new was conceivable in this land where time had been forcibly stopped decades ago. Even the large clock on the wall of the Central Post Office, by which we used to synchronize our watches, had now been obscured from view by a huge portrait of the never-aging and seemingly immortal Leonid Brezhnev.

One dreary morning on my way to school I saw a man who walked quickly past me with a resigned expression in his empty eyes. He was middle-aged, rather worn and haggard, and wearing an old man's fedora. Consumed with his own thoughts, he paid no attention to a woman who was eyeing him with anticipation. I thought this was a good metaphor for how we often are too consumed with ideas to notice the prizes life has to offer. Then I felt a pang of fear that with a few added years I might grow to be like this man in his standard-issue fedora: gray and expressionless, tired of

living, and indifferent to the opposite sex. That image stayed with me all day, and in the evening I drew it from memory, using my own reflection in the mirror as a prop.

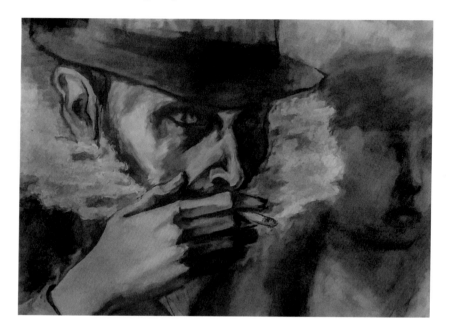

The news media perpetually celebrated our country's successes. They didn't simply embellish reality; it was as though they reported from a different planet. It dawned on me that our journalists were probably using the creative method of socialist realism: rather than reporting the facts, they described a perfect, superior world, which the rest of us had to live up to.

It was similar to the mythological proto-world I imagined while drawing Athena: a parallel reality of immortal gods where perfection sprang into being. Planet Earth was only a feeble reflection of that superior planet. Our cities and villages, our schools and factories, our stores and apartments, all the

other countries and their inhabitants: they were all distorted reflections of some perfect idea. That superworld had a name and a mailing address: the Department for Agitation and Propaganda of the Central Committee of the Communist Party, whose collective mind was swirling in an endless cataclysm of creation, in an almost mythical place called Moscow.

We who lived in the flawed world obviously had flawed minds, and any opinion we formed on our own was unfit to share with others. We were only allowed to hold and share perfect opinions given to us by our gods from the perfect world.

The unintended consequence of that was the rise of a culture of political jokes. A safe alternative to forbidden opinions, the jokes were funny as long as the listeners shared the same opinion of the issues that could not be named nor debated. The sheer volume of political jokes told throughout the country seemed to prove that most people believed their own eyes rather than propaganda. Laughing at our absurd predicament and unable to do anything to change it left us in a degraded and humiliating position. There was nothing we could do about that either.

I liked the joke about a man who was handing out blank sheets of paper on Red Square in Moscow. The KGB arrested the man, looked at his leaflets, and realized that they were blank. "Why didn't you put a political message on your leaflets?" they asked. The man answered, "Why bother? There's nothing I can say that people don't already know."

3

Unsure what to do with my life, I chose to get a diploma in English. For a young provincial man, a career in foreign languages was about the only chance to see the world and, with some luck, avoid the boredom of a politically correct existence.

Higher education was free but inflexible. The curriculum was set in stone from the first day to the last. No classes were electives. Applicants had to take oral and written entrance exams at a college of their choosing. With all exams held simultaneously throughout the country, failed applicants had to wait until the following summer to apply again. Military draft among boys often delayed that chance for two more years. College postponed the draft until they earned a diploma; then graduates still had to serve for a year, unless they took a military officer class. The latter wasn't an elective; if a school offered that class, one had to take it.

Upon graduating high school in 1977, at my mother's urging, I traveled as far as Leningrad University. No one in Leningrad cared for a kid from Ukraine with an odd Armenian last name; they had to meet geographical quotas for students from their own region.

I came back home and got a job at the local Souvenir Factory making knick-knacks out of flexible brass sheets. Of course, I was more interested in creating my own designs, but that wasn't allowed unless I sold them on the side and shared the revenue with my boss. That's what most people did, but my projects weren't for sale and I had nothing to share. Everyone thought I was either lying to them or I was an idiot; either way I didn't fit. After several months of bickering I quit, or else I'd be fired with a permanent stain my work record.

Resumes didn't exist. No one would believe a piece of paper if it wasn't a state-issued form, signed and stamped by an authorized official. Every Soviet adult was issued an official work record-book the size of a passport, where our employment history was filled out by administrators: dates, positions, and reasons for termination. A record of getting fired would last a lifetime. Long delays between employment posts weren't good either. Not working wasn't an option; one would be harassed by the police and forced to get any available job or be charged with parasitism and sent to a correctional labor camp, with a corresponding entry in the work record book.

I soon became a die maker apprentice at a facility that was part of the military-industrial complex, disguised as a "Radio Factory." The running joke was that if you were to steal some parts and try to assemble a radio at home, the end result would be a surface-to-air missile. So that no Western spies

could count its workers or tried to recruit them, we were asked to tell strangers that we worked at the Fertilizer Plant. My job was to form steel blocks into dies for punch presses based on technical drawings. The supervisor praised my grasp of the trade but I didn't care about it: this job was only to bide my time until college.

My birthday in the summer allowed me to skip the spring draft and take the college exams before the fall draft would sweep me away to the army. This time I played it safe and applied to the local Teachers Training College. I soon was a student at the Department of Foreign Languages.

Because education was free, anyone could apply. Because it was inflexible, college was full of young people who had no idea what they wanted to do and simply waited to get some kind of a diploma and then see what happens. Just like in junior school, we were divided into permanent groups that stayed together until graduation, all taking the same courses. Also, like in junior school, I was drawing pictures during classes.

I loved learning English: it was the language of rock and roll. Our propaganda denounced rock as decadent bourgeois music and a tool of Western imperialism. That only pushed more young people away from communism and into the underground record exchange, where they acquired commercial skills and the appreciation of the free markets.

These days anyone can type a song's name into a smart phone and a music video will pop up, or a page with the lyrics. Back then we'd rewind the tape over and over, trying to make out the words and writing them down one at a time. Then we'd read

them as a poem, trying to understand the song's meaning. Whenever an album came with the lyrics, I wrote them into my notebook. I remembered hundreds of songs and could sing almost the entire Beatles collection. Rock filled my head with more English phrases than existed in our textbooks, and that inadvertently put me ahead of my English class.

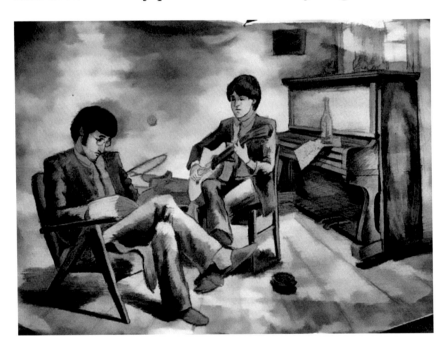

John Lennon and Paul McCartney never sat around my house while wearing my old slippers. But quite a few of my friends did. Whenever my parents were away, my friends treated my house as a social club where they could play music, read books, drink wine, smoke cigarettes, and talk all kinds of nonsense. Out of boredom I once drew a couple of them in my living room. They were practicing playing In My Life by the Beatles, so I changed their faces as if they were John and Paul wearing their Beatle jackets and ties. I kept everything else,

including the slippers, the wine bottle on the piano, and the ashtray on the floor that looked like a flying saucer. This was in the late 1970s.

Immersion in another world through music was liberating. Our teachers were telling us that the West was a dark and soulless world overtaken by fear, injustice, and violence. But its music told a different story: it could not have emerged from such a dark place and could only exist where people were free. Whether the musicians intended it or not, to me at least, their songs spoke of freedom, and that was the best part. Listening to their music made me feel free.

We were taught to believe that freedom resulted in crime and depravity, that without the full control of the state we would all die in a bloodbath, and only the Communist Party protected us from chaos and death. At the same time we were told that our ideology was "historically optimistic." I kept thinking to myself that if America trusted its citizens with their freedom, that country was way more historically optimistic than our people's state whose leaders taught us to fear freedom and restricted our natural liberties, allegedly for our own protection.

When the weather was good I preferred walking or riding my bicycle. City buses were cheap but too crowded during rush hours and rarely ran on schedule. On my walk home from college, I'd squint my eyes and imagine myself in a vibrant Western city, as I had seen them in smuggled magazines and occasional movies. I imagined walking past well-maintained buildings, cozy cafes and restaurants filled with friendly people, and cheerful private stores with imaginative signs over

welcoming front windows. Those stores offered delicious food, fashionable apparel, uncensored books, modern household gadgets, colorful toys for children, musical instruments, songbooks, and the latest rock and roll records, which I could browse and buy at a regular price without looking over my shoulder.

My city could look like that, too, I thought, if it hadn't been for the communists with their revolution and their strategy to achieve abundance by making us live in squalor, obey the Party elites, and worship the stone monuments of their leaders.

What we had in abundance were classes in Marxist curriculum. Receiving a college diploma was contingent on our ability to memorize and internalize Dialectical Materialism, Historical Materialism, Political Economy of Capitalism, Political Economy of Socialism, Marxist Ethics, Marxist Esthetics, Scientific Atheism, and the most important of all, Scientific Communism.

Those courses had been frozen in time, like the country itself. The only conceptual updates since the 1917 revolution took place in the 1950s, with the purging of all references to Stalin, and in the 1970s, with the addition of a new theory of "developed socialism." The latter postponed the arrival of real communism into a distant future, which reminded me of my fight with a teacher who had promised we would see it in our lifetimes.

History of the USSR was a forever living and breathing course, where historical facts always changed to fit the current events - as opposed to our future, which was set in stone. In short, everything that happened before the revolution was evil and dark, but now our future was bright.

The Marxist version of world history claimed that the ruling classes, the rich, and the clergy had for centuries conspired with one another across

national borders, always inventing new painful ways to oppress the downtrodden and to feed on their suffering. In the capitalist sector of the world, the masses still suffered in terrible pain, but we were in luck because Lenin's revolution had liberated us from such misery. It sounded like a mad conspiracy theory and I often wondered if our teachers believed their own words. If they didn't, what was their goal? It was fun to imagine an absurdist conspiracy among our educators to discredit communism by shoving it down our throats in the most unpleasant ways, which prompted us to look for alternatives. The idea of our teachers being secret agents of freedom was hilarious.

Marxism argued that societies lived and died according to a predetermined sequence, inevitably giving way to more efficient and progressive societies. Thus, humanity started with primitive communism of hunters-gatherers, then came tribalism, then slavery, then feudalism, then capitalism, then socialism, and the final inevitable step would be a return to communism, albeit on a higher level, completing the twist of the evolutionary corkscrew. They lost me with socialism though, which felt more like a regression to feudalism under a different label.

I could see how, many years ago, the industrial revolution would have resulted in resentment and longing for the idealized certainty of feudalism. Some couldn't accept a society where the free markets allowed uneducated shopkeepers and engine mechanics to wake up millionaires, while refined aristocrats often went penniless. It seemed unfair

that money ruled while quixotic passions and heroism became a joke. Poets sold the dream of a bygone era where benevolent overlords took care of loyal peasants. That poetic mirage was more appealing than the prosaic reality of money and profits, where every man was responsible for his own destiny. Eventually some sappy thinkers invented "feudalism with a human face" and called it socialism. If the USSR were one day to go back to capitalism, I thought, we could expect a similar longing for the certainty of the good old days.

I imagined that Marx would have been terrified by the USSR: this surely wasn't what he had intended. He would also be dismayed by all the other Marxist regimes, no matter what continent or cultural background. Perhaps, the flaw was not in the implementation, but in the ideas themselves, which always led to pathetic results.. If a theory consistently failed in practice, it was probably not so great to begin with.

Thinking about it made me draw an eerie specter of Don Quixote, the feudal fossil that haunted the capitalist world. He lurks outside its neon-lit cities and waits for an opportunity to attack its industries that are the updated windmills. I took Picasso's famous ink sketch and redrew it as a literal representation of Don Quixote's skeletal figure in three dimensions.

To the Spanish communist Pablo Picasso, Don Quixote may have been a heroic, if comical social justice warrior. To Miguel Cervantes, who had created this character four hundred years ago, Don Quixote was an archetypal delirious fruitcake who wanted to change the world by turning the clock back to the idealized era that had never existed.

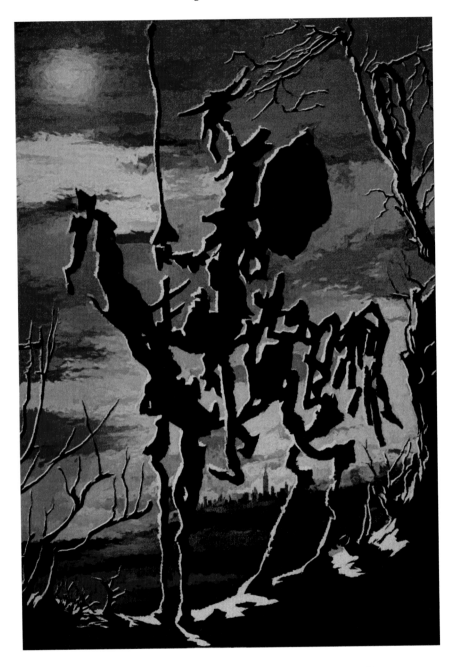

To show his contempt for this character, Cervantes used a Catalán slang word to name Don Quixote after the horse's hindquarters. He added "mancha" to his

full name, which means "stain." The horse's name, Rocinante, meant a "reversal." The entire novel was a satirical farce about a retrograde who fought societal progress and human nature itself. A large part of the book details his hallucinations.

In a tragicomical twist, delusional humanity reversed the author's intention, turning a lunatic into a seminal hero. Imagine what Cervantes might write today about this "modern" interpretation of his satire.

Nevertheless, Marxism was the only philosophy known to us, and its imprint on our minds was inevitable.

One day I sat on a park bench with a girl named Anastasia after we both attended a lecture on Marxist philosophy. I wanted to ask her out, but instead of saying the words I kept talking about how we could extrapolate that recent lecture to mean that our sexual life should not be constrained by the same morally bankrupt shackles that had been the impediment to the previous generations of young people. According to Marx and Engels, family in the previous socio-economic formations was clearly the product of private property, which prohibited premarital sex for women and chained them to their husbands so that men could pass the inheritance to their own seed and not to that of their neighbors. And the fact that our authorities still forced us to live by the bourgeois morals long after the socialist revolution was just another proof of our society's total hypocrisy.

She looked me straight in the eye. "Do you want to have sex?" she asked.

"Yes," I said.

"Then let's go to your house and stop with this Marxist nonsense."

This was soon after I'd broken up with a beautiful hazel-eyed girl who'd been obsessed with marriage and having children. I told her I wasn't ready for children yet. She said I had disappointed her, called me an irresponsible child, and tore up all of my drawings of her. She got married a few months later to someone I knew, and I wasn't impressed. By some miracle one drawing had fallen under the bed and survived her rampage.

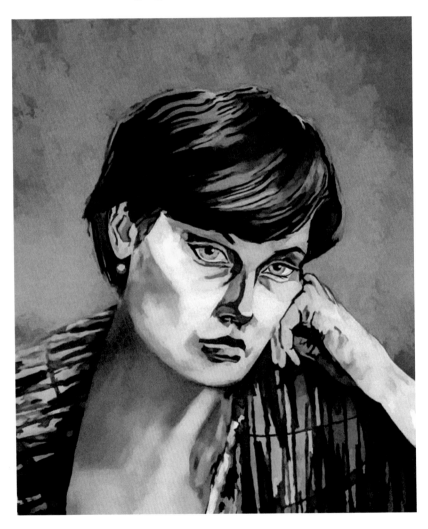

Anastasia became my girlfriend and later played a big role in my life, but at the time I was glad she just wanted to have fun without commitments. I never spoke to girls about Marxism again.

4

One spring day our teacher told the class that the best student would be selected for a brand-new summer exchange program: an all-expense-paid, two-month advanced language course at Oxford University in England. Everyone looked at me: as far as English was concerned, I was the best student. And though I didn't pay as much attention in other classes, I wasn't a slouch either. The teachers would make their picks, but the final decision was up to the dean.

Visiting England had been my long-time dream. Weeks passed in anticipation. I imagined the stories I'd tell upon my return; perhaps I could even give talks on campus and beyond about the English life and customs, share my experiences, and even teach an optional class on the advanced language course to students and teachers alike.

Our dean disliked me from day one. It was as if our brains were running on incompatible operating systems. A small and bitter man with the manner of a drill sergeant, he never missed an opportunity to find fault with me. Still, I was the best in my class and that had to account for something. Having been called to his office on another matter, I brought up the Oxford summer program.

"Oxford?" he laughed. "You?"

"Why is that funny?" I asked.

"You're going nowhere," he scoffed angrily. "Anything else you'd like to know?"

"If there's a reason, I'd like to know it."

"You are politically unreliable, is that a good enough reason?"

"How am I politically unreliable?"

"Last week you embarrassed our school before a guest lecturer from the Knowledge Society. That woman came all the way from Moscow to educate us, and you acted as if she didn't know what she was talking about."

"She didn't."

"That's ridiculous," he laughed. "How can you know more than the Knowledge Society in Moscow?"

"Her lecture was titled, 'Rock music as a tool of capitalist propaganda,' and she couldn't even get anyone's name right. She said the Beatles consisted of John Lenkov, Raul McCartneigh, Rancho Starr, and Georg Narrizon. Suppose she were to talk about Marxism-Leninism and called them Vladimir Marx and Karl Lenin; would you think she knows what she's talking about?"

"Stop disparaging Marxism-Leninism!" the dean growled. "I won't allow it in this institution of higher learning!"

"That's not what I mean. She also said that the rock opera Jesus Christ Superstar was manufactured by the bourgeois ruling classes in order to subvert the Soviet youth by promoting a hateful cult. She couldn't even say 'Jesus Christ' in English without botching it. That means she never even listened to the opera, or she would've heard the name."

"And how do you know that?" the dean squinted. "Are you saying you've actually listened to that

bourgeois propaganda designed to subvert the Soviet youth?"

"English is my specialty and I know how to say words," I said evasively. "Aside from the language, she said the opera compares people to spiders in a jar who fight each other because they've been poisoned by propaganda. Nothing in that statement makes sense."

"Well, would you like to be poisoned by propaganda?" the dean asked. "How would that make you feel?"

"I guess the same way I'm feeling right now," I said.

"See what I mean? You've already been poisoned. You would only bring shame on our school and on the Motherland. We have a much better candidate who we're confident will proudly represent us in Oxford."

"May I ask who?"

"That's none of your business. It's funny you even thought I'd ever consider you. You're damaged goods."

I went home thinking about the meaning of "damaged goods." It made me feel like a one-legged wino sitting in the dirt at the farmers' market, smelling of urine and begging for change, with passersby pretending I didn't exist and shielding their children's eyes as if that could make me disappear.

The summer came and went. The student who spent two months in Oxford didn't talk much upon his return. He was a son of a politically connected father, and even though he wasn't the sharpest pitchfork in the barn, he was smart enough to keep his mouth shut. We heard nothing about the advanced English course or about his impressions of England. I could now see why: not saying anything

was the best way not to say anything politically erroneous. No doubt he had shared his impressions with the debriefing KGB officer, and remembering any additional details wasn't advisable. All I learned about his life in Oxford was that he'd used his allowance to buy a pair of blue jeans, and I knew that only because he sold them to my friend for two hundred rubles.

I continued to work on my English degree, although the point of that was moot since I was damaged goods. The secret door to the outside world I had hoped to open with my college diploma didn't exist. The label of political unreliability was the kiss of death to any further aspirations, international or domestic.

Then someone gave me a book about Van Gogh and it worked as a bottle opener, releasing the desire to paint that had been brewing inside of me. It could have been another book, or a film, or a painting, but I'm glad it was Van Gogh. The world around me was now filled with magic colors that begged to be captured on canvas. I saw red and yellow leaves lying in the puddles amidst the deep-blue reflections of the autumn sky, and missing the opportunity to paint them caused me an almost physical pain.

This obsession felt like insanity, especially considering that I had no art supplies, let alone the training. I hadn't even finished my teenage wall drawing. I wanted to study art, and fortune smiled on me this time. It turned out that the Palace of People's Friendship, whose construction a block away once sent armies of rats into our yard, now had a public art studio. I found it on the second floor, went in, and saw the instructor who was only a few years older than me. His name was Yan

Martsinkevich, and he turned out to be the best art teacher I could ever hope to find. Seeing my motivation and talent, he gave me a set of his own paints, along with plenty of advice and encouragement. We became fast friends.

Yan's paints were a good start, but I hated being a leech. I went to the House of Artists, which I remembered had a small art supply store. The old building now had a new five-story addition with art studios at the top and a handsome coffee shop at

the bottom. The bright sunny day was in tune with my spirits; life was wonderful.

The art store had no customers. A lonely saleswoman behind the counter stood with her arms crossed over her chest, like a fairy-tale dragon guarding the shelves with precious brushes and paints behind her back.

I put a pile of cash on the counter; it was all the money I had. I hoped it would be enough for a box of oil paints, a jar of white lead, a can of primer, some canvas, and a few bottles of linseed oil and turpentine.

"Got an Artists Union card?" she interrupted my wish list.

"What's that, like a permit to paint?" I asked.

"Art supplies are for union members only." She sounded bored.

"Then how do I become a member?"

"If you don't know that, there's no point asking."

"Please?" I said, feeling small.

"Did you even go to art school?" she said, staring at the ceiling.

"I'm taking art classes."

"To become a Union member you need to have art exhibits and recommendations from other members," she droned.

"How can I have exhibits without the paints?"

"And how can you be a painter without a state-issued diploma?"

"Did Van Gogh have a state-issued diploma?"

"I've no idea, why don't you ask Van Gogh?"

"Let me get this straight," I said. "The state decides who can be an artist, and all the others by default are non-artists?"

"More or less."

"How come the state never issued me a non-artist card?"

"Don't give them ideas."

"So if I don't have my non-artist card, how do you prove I'm a not an artist?"

"A wise guy," she scoffed. "If we start selling to anyone who waltzes in here, there won't be enough left for the real artists. We've got quotas and rationing."

"That rationing is the crux of the matter, isn't it?" I said. "Central Planning strikes again. Socialist distribution versus the free markets." Once again I felt like an invisible beggar at the farmer's market, mumbling nonsense to passersby. The words "damaged goods" crossed my mind and it made me angry.

"Be my guest, call the Kremlin," she rolled her eyes. "Maybe they'll overhaul the Five Year Plan by request of the toiling masses."

"Or maybe we'll overhaul their stupid system," I said a bit louder than I intended.

"Or maybe I'll call the police," she touched the telephone on the counter.

"No need," I said on my way out. "I'll deliver the news to my non-artists union."

Yan later laughed at this story and gave me some friendly advice.

"Buy a few bottles of vodka. There's a less snotty art studio complex on Cosmonauts Street, I'll give you the address."

"Another arts supplies store?"

"No, but those boozehounds will barter anything with you for a bottle of sauce."

The art complex was forty minutes away from downtown by bus. It turned out to be a long wooden barrack, lodged between warehouses and grimy housing projects. Compared to the House of Artists, it looked like the Ghetto of Artists for the less connected. All the doors were closed except one. I walked inside and found myself in a large, messy room.

Three middle-aged guys turned their heads from their canvases. The one closest to me was painting a portrait of a smiling little girl with a large white bow on her head. He was copying it from a formal school photo pinned to the easel's corner; obviously a private project for some adoring family member with money to spend.

"Comrade artists!" I said. "A friend tells me I can trade art supplies here for vodka." I opened the bag and put three bottles on a disorderly table by the door.

"You have a very wise friend," the man in front of me said; the other two nodded in agreement. He walked over to a cluttered shelf. "Give me your wish list."

I left with all the supplies I needed to sustain me for a few months, in addition to plenty of useful professional tips from the friendly trio. I'd visit them again, I thought, pondering the advantages of private arrangements over the state-run commerce. I got no canvas primer, and framed canvases were too expensive on my poor student's budget anyway. I planned to cut corners by painting on pieces of pressboard covered with wall paint.

I went on a painting spree without delay.

5

My art binge ended abruptly after I fell off my bicycle and broke some bones in my right hand. With my dominant hand in a cast, all I could do was wait. A couple of weeks after the accident, as instructed, I was back at the small downtown trauma center for an X-ray, to make sure the bones had rejoined correctly. The doctor was a neurotic old man with a full head of graying red hair. Speaking fast in deliberately short phrases, he sounded as if he were

handling a major crisis in a field hospital during battle, making instant life-and-death decisions. I found it a little odd considering that I was his only visitor.

"You're good," he said curtly. "The cast comes off in a month, then it's back to your job."

"Are you sure?" I said, studying the X-ray film he was holding. "That bone seems to be at a wrong angle."

"Are you telling me how to do my job?" he snapped. "Are you calling me incompetent?"

"My cast feels loose," I said in my most amicable voice. "The bones may not be held together right. It feels funny."

"Feels funny? You want us to redo it?"

"That would be good."

"So that you can add two more weeks to your medical leave? What else do you want, a medal for heroism? I've seen fakers like you before. How do I know you're not messing with it at home so you can stay off work longer? You'll be back to work in a month. Case closed."

"Never mind my work," I said, meaning to tell him I was a full-time student, but he didn't let me finish.

"The nation needs workers," he declared in an affected voice. "This country has given you everything, and this is how you pay it back? By looking for excuses to lounge about? If we're all in one boat, we must all work for the common good! Pull an equal load! Who's going to work if everyone goes on medical leave? I wish Stalin were back, he knew how to deal with sponges like you."

"Is there someone else I can talk to about replacing the cast?" I asked.

"We are done here. Next!" he screamed into an empty hallway.

It seemed I had no choice but to trust the judgment of a man who acted as if he were auditioning for the role of a triage medic in some black-and-white war movie. I wondered how many of his patients had become crippled beggars throughout his long career.

When the cast came off in a month, my right hand had a large, freakish lump. The badly applied cast had caused the bone to rejoin at a wacky angle, pulling most of my little finger inside the swollen hand. The fingertip with the nail was poking out of the bulge like the head of a turtle. I went to face the same redheaded doctor again.

"Your hand looks fine," he scoffed. "Take it like a man and go home."

"It's not fine," I said. "It could have been saved a month ago. But you turned me into a cripple by refusing to change the cast. I want to know why."

"Crybaby!" he shrieked, his face instantly red. "During the war people had injuries worse than yours! And no one complained! They grabbed their weapons and went right back into battle!" he started pushing me out of his room. "And you're just a wimp! With soldiers like you, how can we ever win another war? For all I know, you could've injured yourself to avoid the draft. There's a prison sentence for that."

"So now you want me to be a soldier? Last month you wanted me to be a worker, and look what you did," I held my disfigured lump in front of his face. "This isn't a working hand."

"You can still hold a shovel," he kept pushing me out. "If not, the state will find you some other productive work."

"A shovel?" I laughed, holding on to the doorframe. "What if I'm an artist? Or a musician? How can I draw or play music with these fingers?"

"What kind of a sissy are you? You should be grateful you received free medical care, paid for by the people's state! And how are you paying it back, by drawing doodles? What good is that tripe to the state? Get out of my face, you ingrate, or I'll call the police and tell them you're dodging the draft and spreading falsehoods about our healthcare!" He slammed the door in my face.

Yan suggested I visit the surgical wing of a new city hospital, an hour away from my home by bus. I went and spoke with a surgeon there. He was a tall, handsome young man who still cared about his work. "I wish you'd come to us when you spotted the problem," he said. "Now we'll have to cut into your hand, break the bones, and insert two steel spokes. You'll wear the cast for a couple more months, then we'll have to cut it again to get the spokes out. But I have to warn you: the hand has too many nerve endings which can't all be dulled with local anesthetic. Prepare to take some pain." He made no comment about the job his older colleague had done on my hand.

Two months later the pain was forgotten and, apart from the scars, my hand looked normal again. I still had no feeling in one edge of my hand and my finger wouldn't bend; that required visiting a physical therapy clinic for a few more months. The woman who treated my hand was committed and competent.

"Your free healthcare is only as good as the underpaid and worn-out doctor who treats you," she said. "They all work one and a half shifts."

"You seem to be doing a good job," I said.

"Everyone's different; it depends on one's personality. Besides, I have a husband who takes care of me."

"I hope he's not a doctor working one and a half shifts," I said.

She laughed. "Do you know why most Soviet doctors work one and a half shifts?"

"No, why?"

"Because if they work one shift, they have no money to eat, and if they work two shifts, they have no time to eat."

"That explains a lot," I said. "The state is wasting a fortune on my treatment because my first doctor wasn't paid enough to care. In England they call it 'penny wise and pound foolish.'"

"Have you been to England?"

"One time I almost made it."

6

During one of my college summers my friend and I visited Central Asia on a two-week union tour of the Soviet republic of Uzbekistan. Trade unions were in charge of the workers' leisure and organized free or subsidized tourism around the country. To go on a union trip or to stay in a resort, one had to be an exemplary worker, or to have useful connections. My friend's father knew someone at the regional union office and procured an all-expenses-paid tour for the two of us. The trip gave me a few weird memories which don't belong in this story, except for one episode.

In the late 14th century, the ancient city of Samarkand was the seat of the merciless conqueror, Tamerlane, and the center of a vast empire stretching from Syria to India. In the early 1980s it was a provincial Uzbek city in the middle of a dusty desert, with rickety minarets tipping in various directions and decrepit historic buildings. Our program included a stop at a local medieval prison called a *zindan.* The word "prison" was misleading because it was more of a brick shed with a hole in the floor. The hole opened to an underground pit where prisoners lived for long periods of time, eating whatever food their relatives threw down that hole. One could only get out when the guards dropped down a rope.

A friendly passerby stopped to ask us how we liked his city. He could tell we were tourists by our faces and by the way we were dressed. He then told us that in the days of Tamerlane, people lived under true communism. Everyone was conscientious and honest, because if you stole as much as a fig on the market, the Sharia court would chop off your hand.

And now, he said, there was just too much corruption. In the absence of strict Sharia, people had grown greedy and selfish. That made him wish for the return of Tamerlane and Sharia courts, and for the reopening of the *zindan*. He already knew whom to throw down that hole.

Near one of such landmarks my friend and I passed by a long-haired young man about our age. He sat alone on a bench next to his dusty backpack and was sketching the historic Registan madrasa. We split from our tour group and approached the artist. He introduced himself as Sasha, a hippy from Moscow, and asked for a cigarette. He was there by himself, hitchhiking from one place to another and sleeping in the desert on his camel-wool blanket. We invited him to sleep in our union tourist complex, which consisted of several low-end plywood barracks and a cafeteria that served free meals. For a few nights he slept on the floor in our small room, using his camel blanket and eating free food at the cafeteria, posing as a union tourist.

Sasha filled us in on the latest developments in Moscow. He spoke about the vibrant world of underground music and literature, reciting long poems by dissident authors from memory. Without an independent media, this was our only way to hear about this kind of news. We were grateful for the enlightenment. He also praised the high quality of Uzbekistan's wild-growing hemp. My friend and I knew nothing about that. According to Sasha, hashish was widely available at the farmers' market. Everybody was smoking it, from farmers to policemen. He said the locals added hashish to traditional food at various parties, weddings, and other celebrations, as an adequate substitute to vodka. Though Islam was officially suppressed, local

Islamic traditions remained, and they forbade alcohol. Hence, just as the state had replaced Islam, hashish had replaced booze.

As my friend and I digested this information, Sasha asked us for a few rubles so that he could procure some local hashish and disappeared with our money. In the evening he returned to our room with a matchbox filled with some brown resin. He emptied a cigarette into his hand, mixed the loose tobacco with the resin, and carefully stuffed the mix back into the cigarette tube. I made a sketch of him doing that.

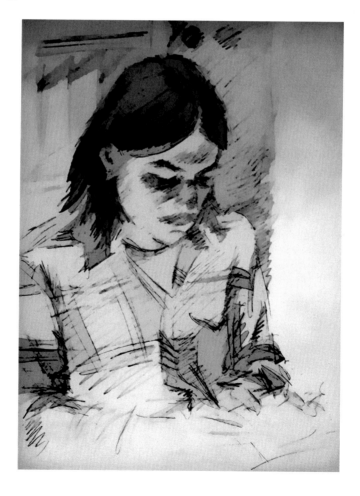

Once the cigarette was ready we went outside and sat by a dark road. Just as Sasha lit up the match and made the first draw, a police car came out of nowhere and flooded us in the headlights. The policemen ran out of the car, put us in handcuffs, and searched our pockets. On the way to the police station, Sasha instructed us to blame everything on him because he was a certified lunatic and couldn't be prosecuted; he had a paper from a mental institution in his backpack.

A young police lieutenant at the precinct interrogated us in Russian with a strong Uzbek accent. He kept wondering how exactly we'd arrived at an idea to smoke hemp. He wasn't pretending: he sincerely wanted to know what made us do it. My friend and I confessed that we'd recently seen a Soviet documentary that warned our youth about decadent capitalism and exposed such evils as sex, drugs, and rock 'n' roll. The scenes where people smoked funny-looking cigarettes made us curious, we said.

Sasha refused to answer any questions. Instead, he loudly proclaimed that he was a hippy and police brutality was cramping his lifestyle. A sergeant took him into a cell with his arm twisted behind his back and we never saw him again. My friend and I were released with a warning after we promised not to do anything stupid.

During my visit to Moscow a few years later, I dialed the number Sasha had left in my notebook. His mother picked up and cautiously asked who I was. I mentioned Uzbekistan and she gasped. "Sasha isn't home," she sobbed and hung up.

Years later I visited California where people consumed marijuana in all its forms, from vapor to food. It reminded me of the Uzbekistan of Sasha's

stories. I was still curious to see what all the hype was about and it wasn't long before an opportunity presented itself. The joint made me dizzy. I didn't like the way it made me see people around me and it definitely wasn't worth being arrested in Uzbekistan. That satisfied my curiosity and I never tried it again.

7

My final year in college began with a one-month teaching internship in a real school setting. The luckiest interns stayed in the city, assigned to local schools. The medium-lucky were sent to nearby towns. I was assigned to the farthest village on the dean's list, four hours away by long-distance buses with a transfer. Considering our six-day school week, that meant I wouldn't be coming home on weekends.

Bus passengers threw curious glances at my easel on the overhead rack. When the road became too bumpy to read a book, I started eyeing them too, trying to guess their professions and where they lived. Farmers were easy to spot by their frumpy, old-fashioned clothes, padded jackets, and tall oilskin boots suited for working in the dirt. The farther the bus went, the more oilskin boots and padded jackets were on it, until I was the only one left wearing a T-shirt and light sandals. As the bus made stops in different villages, new arrivals cheerfully greeted everyone and joined the general conversation, joking and laughing as if they were at some large and noisy family gathering.

Suddenly a middle-aged woman in a yellow headscarf started singing a Ukrainian folk song. On a city bus she would come off as a crazy person, but on this country bus all the men and women eagerly joined her, bursting into a spontaneous polyphonic harmony. They all knew the words and could carry the tune. When they finished, a man sitting next to me started another song and everyone followed. The singing went on after my seat-mate exited the bus: new passengers joined the chorus even before they took their seats. I remembered such massive singing from the time I was little, but by the time I grew up that kind of song culture had vanished from the cities. I was glad to find it still thriving in the country.

Once I started to teach at the village school, a shy fifth-grader confided in me that she thought the city people were weird. "My mom and I went to the city one day," she said. "And I was saying 'hello' to everyone, but nobody nodded or smiled at me. So many people in the streets, and no one greeted me back. Then my mom told me to stop saying 'hello' because they would think I'm crazy. Why is that?"

I had no answer. Years later, I remembered that girl every time a smiling passerby greeted me on American streets. Perhaps our people also had smiled and greeted each other as friends until the state ordered them to be comrades. One way to end a friendship is by forcing people to share everything against their will. In a state founded on charitable ideals, private charity ceased to exist. A cultural transformation was easier to accomplish in the crowded cities, but old ways still survived in the heartland. That, I think, would answer the girl's question.

In the village of Yaroshivka I discovered a lost, peaceful world. Not a soul knew a word of English.

The previous foreign language teacher had left six years ago; according to local gossip, she married a Jew from a nearby town, and they emigrated to Israel. In the absence of an instructor I was left to my own devices. Teaching the basics was easy and required little preparation. As soon as the classes were over, I'd grab my easel and wander off into the countryside. Not only was it a lovely area, but early fall was the most wonderful season.

At the end of the month my school informed me that my dean had extended my internship until November at their request. I was delighted. What he meant to be my punishment had become a gift of beauty and freedom.

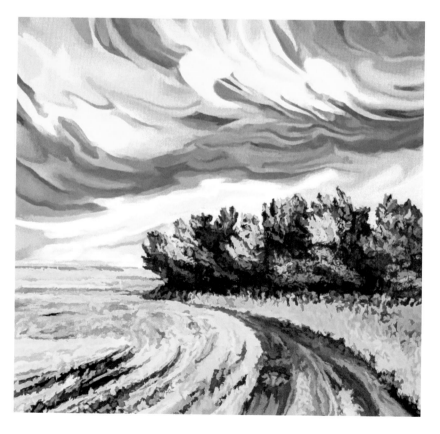

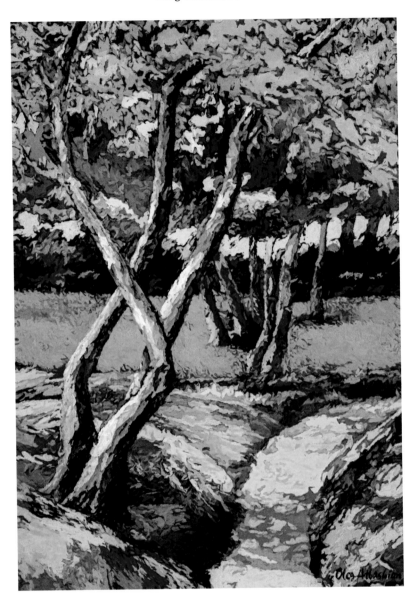

I was given a room in an empty workers' dormitory that belonged to a small state-run sugar factory. The pungent odor of processed sugar beets from the factory spread around for miles. It probably helped to disguise the stink of illegal stills in many a backyard shed, where the locals turned pilfered molasses and

sugar into moonshine, to each according to their needs. While many villages claimed the jocular title of the biggest Soviet moonshine producer, this one surely had the resources to pull it off, with sugar beets being the main crop at the local collective farm.

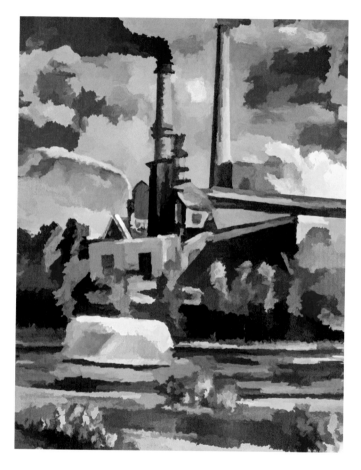

In some ways, the abundance of sugar and moonshine compensated for the scarcity of just about everything else. For the two months I lived there, the school cafeteria served nothing but bowls of boiled barley with a layer of sugar on top. Teachers and students ate better meals at home. I was stuck with barley.

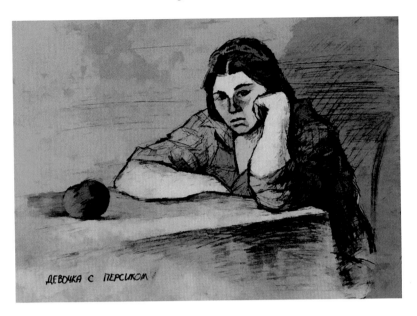

ДЕВОЧКА С ПЕРСИКОМ

A young village woman once brought a boiled potato to my dorm room because she thought I might be hungry. Another time she brought me a one-liter glass jar of fresh milk, and the next day a jar of fresh moonshine. She said she'd never been farther than 50 kilometers outside the village. Being from a big city made me a rock star in her eyes. She said she dreamed of going far, far away, and of trying various exotic things, like peaches, which she had never eaten. As we talked about her life and the finer points of distilling beet liquor, I started sketching her sitting at my table in front of the potato. Then I scribbled "A Girl with a Peach" over the page in Russian, referring to a well-known classical painting.

I didn't want to raise her expectations; I was sent to her village only because I was damaged goods to my dean. With nothing to offer in return, I declined her further gifts. To make it look less like a rejection I told her I was in love with a girl named Anastasia who waited for me back home.

I wished that were true. Anastasia had married a promising star athlete and moved with him to another city. She had told me that she loved me, but athletic achievers were among the few elite groups above us, the unwashed. In those terms I was just what my dean thought I was. Anastasia had to think of her future children. She didn't want to grow old and raise kids in a house without indoor plumbing, carrying buckets of water, burning coal for heat, and relieving herself in an outhouse full of mouthy rats that sang like birds inside the pit.

On Sundays I went out early, to capture the midday sun. On school days, I'd set up my easel by four in the afternoon and painted until sunset, often redoing the previously applied colors to capture the changing light.

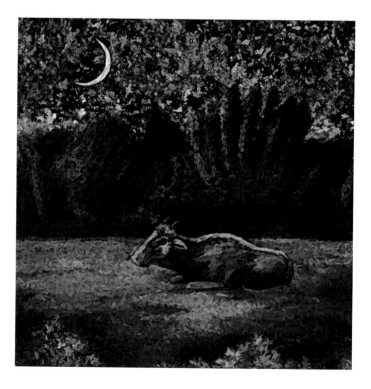

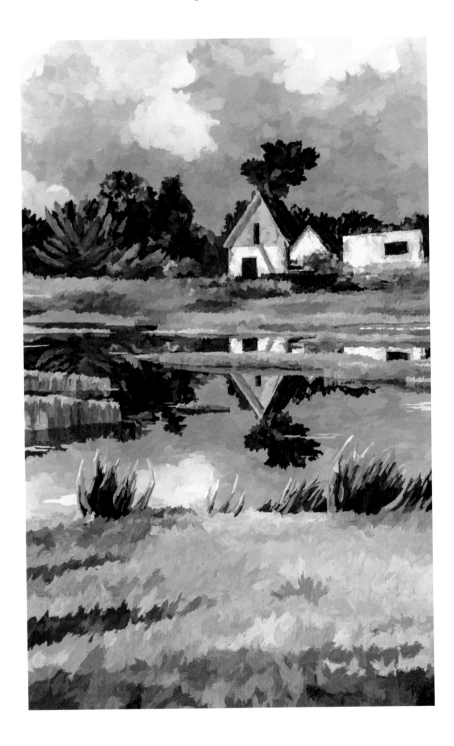

The dorm had a communal kitchen with a stove, but I had nothing to cook. There weren't any fridges, and my room had no sink. The nearest faucet was in the bathroom across from the useless kitchen, a few doors down the corridor. A small state-run store two miles away sold nothing but sugar, yeast, and canned fish in tomato sauce. Its empty shelves had plenty of dust but never a loaf of bread.

The locals, I found out, grew food in their gardens and baked their own bread. They privately raised pigs, chickens, and cows, made their own cheese, butter, and sour cream, and bartered surpluses with their neighbors. This was a medieval economy of the feudal age. The mandatory collectivization of private farms in the early 1930s had turned villagers into serfs. The state had become their new owner, telling them what to do on their collectivized lands, requiring them to meet their production quotas, and denying them internal passports so they couldn't move out. When the liberalization of the 1960s allowed villagers to leave their ineffective farms, they massively moved into cities where labor was needed to build ineffective factories. The state gave them a bed in a dormitory and a temporary residence permit as if they were foreign migrants. Those who remained in the villages ate better than the defectors in the cities, which had intermittent food shortages.

Canned fish and sugar-coated barley kept me going for two more months, but once I returned to the city my stomach gave in. On the ride home I anticipated a welcoming party with friends followed by several days of idle bliss during the celebration of the revolution, which was a state holiday. But as soon as I walked into my house, I vomited on the hallway floor and collapsed. My friends arrived to

the party, found me unconscious, and called an
ambulance. The next two weeks passed at the
Hospital for Infectious Diseases.

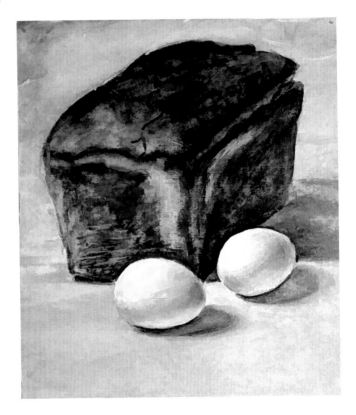

*A watercolor I once made of a
typical meal I ate as a student.*

8

I woke up on a metal spring bed in a room with a
dozen other infectious patients, with cold drafts
blowing through the walls and a family of
cockroaches staring at me from the bed stand. It
was a wooden three-story mansion designed by

some imaginative architect for a wealthy merchant before the revolution, then confiscated by the state and converted into a medical facility. The structure had miraculously survived into the eighties, but cracks in its wooden walls were big enough to see the street. With so many roommates inside such a cramped space, when one of them snored others threw things at them to get some quiet. The most common projectiles were our hospital-issued, one-size-fits-all slippers, which we had to collect the next morning for trips to the bathroom.

Every morning a short chubby woman in a white gown showed up for her rounds, mispronouncing all the names on her list. She never told me her name, nor did she ever tell me the reason for my sickness.

Whenever I asked her a question she'd turn her back and pretend I didn't exist. I could only assume she was my assigned physician. Then a nurse would bring us a tray of brown pills, one for each patient. She never responded when I asked her what medicine it was, or why all of us were given the same pill. It was as if I were a lab rat making noises which she didn't understand.

Years later I watched an American film where Morpheus gave Neo options between a blue pill and a red pill, and flashed back to my options between a brown pill and a brown pill. The state protected us from unwise choices, I thought. In the Soviet Matrix, the pills chose us.

Ever since then, my stomach problems kept sending me back to the hospital every few months, without anyone bothering to explain why, or how to make it stop. The state covered the expenses, but at some point I wished I could see a paid private doctor who would give me his full attention instead of the lab rat treatment. Then I realized that even if private doctors existed in our country, most people including me and my parents would have no money to pay them. Why did our working people end up so poor? Because the state had taken all their money to pay for their free substandard healthcare, whether they liked it or not. This was the invisible trap in which we all lived. That realization shocked me. They didn't teach this in my political economy class.

The more I thought about it, the more invisible traps I discovered. They were all listed in the Soviet Constitution as our guaranteed rights.

We had a right to free education - except we weren't free to opt out of propaganda in our textbooks and our

parents weren't free to save their children from brainwashing. Teachers weren't free to deviate from the Party line and filter out the lies. Upon my graduation, I wasn't free to choose where to work: for three years I would have to teach at a school of my dean's choosing, which I already knew would be in the remotest corner of the map. If private schools even existed, parents wouldn't be able to afford them because the invisible hand of the state had pilfered their wages and spent them on free education.

We had a right to affordable housing - but we weren't free to choose where to live. The majority lived in substandard housing projects, sharing crammed apartments with their parents and grandparents. Children grew up and became parents themselves, still sharing the same space with their own kids and later grandkids. The state was building more housing projects, but the population also kept growing. Almost everyone was on a housing waiting list, but new apartments often took decades. People died, got married, divorced, moved in and out, causing a bureaucratic mess that invited corruption and cheating. So that no one could have more than one subsidized apartment, the state introduced the *propiska* - a mandatory residence stamp in our internal passports. One couldn't get a job without the local *propiska* stamp, and one couldn't get a *propiska* without a local job. To change cities, one needed the equivalent of a work visa or proof of marriage to someone with the local *propiska* stamp. Once such a move happened, a state official would add a new stamp with the address and date in one's passport, but only after another state official at the old location had canceled the previous stamp, terminating one's right to occupy that apartment. To move to a major

city like Moscow was as hard as to immigrate to another country. This gave birth to a bustling black market of bogus marriages, bribes, shadow renting, and multi-party apartment trading schemes with payoffs and kickbacks. Regular working people couldn't afford it because the state had taken most of their wages to subsidize their right to affordable housing.

Our right to work came hand in hand with our duty to work. The state that subsidized our existence mandated that we all contributed to the common good. The official slogan, "from each according to their abilities, to each according to their work" translated into obligatory work for the state with a monthly pittance. A refusal to work was a crime against the state. To guarantee full employment, the state often created jobs that weren't needed, or kept worthless and outdated companies running, which added to the overall inefficiency. People said, "They pretend they are paying us and we pretend we are working."

Free entertainment on radio and TV had its price, too. Commercial-free broadcast ensured an uninterrupted flow of propaganda on all three state-run TV channels. Instead of product placements we had doctrine placements. Instead of hit parades we listened to military parades. Instead of sitcoms we watched endless shows about our country's progress in the manufacturing of industrial and agricultural products, as if plugging a TV antenna into a refrigerator could fill it with food. He who pays the piper calls the tune, and if the state pays for your entertainment, it also chooses what thoughts should be allowed in your head.

9

I liked the joke about a foreign visitor who fell into a Soviet pothole. She called the state-run tourist agency, Intourist, and started complaining.

"In my country, we surround potholes with little red flags as a warning," she argued.

"Did you see big red flags at the border?" the Intourist official said.

"Yes..."

"That was your warning."

Most foreign tourists came to our city on seasonal river cruises. About once a week in the warm months, the large Kiev-Odessa cruise ships stopped, and Intourist guides herded the guests into buses for a three-hour tour of the city. The local Intourist office hired seasonal guides from among the students of our college, and I badly wanted that job. When I was finally hired, it felt like I'd gotten my foot in the door to a bigger world.

Our three Intourist bosses were the coolest guys in town, enjoying themselves at what I thought was a dream job. Their two-room office took the best corner in the lobby of the five-story downtown hotel, right across from Lenin Square. The place communicated a feeling of adventure, as if its windows opened on exciting foreign landscapes with beckoning possibilities.

All Soviet geography was political, dividing the globe into three worlds. The first one was the shining world of socialism that consisted of "soc-countries" with the USSR at the helm. The second one was the dark world of capitalism that consisted of "cap-countries" with the USA at the

helm. The third world consisted of non-aligned countries of Africa, Asia, and Latin America, that were our potential allies but remained a work in progress.

As a result, the Soviet tourist industry judged foreigners based on which side of the Iron Curtain they came from. While foreign travel for us was a rarity, taking a tour to a "soc-country" like Poland or Bulgaria was a lot easier than, say, visiting the "cap-country" of Great Britain, which was officially considered the bulwark of capitalism, next only to the USA.

The treatment of foreign tourists differed accordingly. Eastern Europeans required less work and supervision. These groups came with their own interpreters and our people conducted the tours in Russian. The rare American and Western European groups received tours in English, which for me was an opportunity to test and improve my language skills.

German groups, both "cap" and "soc," visited frequently. They received special tours, custom-made by our Intourist boss named Eugene and conducted by those of us who studied German. Eugene wrote the text himself and gave us his handwritten sheets to copy, memorize, and recite by heart on the bus, regardless of how much we understood what we were saying.

Having only begun taking German in college, I couldn't yet speak in complete sentences, but I could read with a dictionary. When I translated Eugene's copy at home, my jaw dropped. The entire three-hour tour zeroed in on the Nazi war crimes and the destruction the Germans had

wrought on our land, offering it as an excuse for our country's continued poverty. The next time I saw Eugene, I asked him if we could soften the tone.

"They're paying for a fun vacation, not a guilt trip and a scolding from a tour guide," I said.

"Those Nazis deserve it," Eugene chuckled light-heartedly.

"Their only crime is coming to visit us," I persisted. "These Germans are our guests."

"You mean, these Nazis?" he giggled.

"I thought post-war generations had a changed mentality."

"Nazis still."

"Aren't East Germans our allies?"

"Nazis all of them," Eugene stopped laughing. "They deserve all of it and more."

"Fine," I said. "But then there's also this part where we blame Germany for our failures."

"What about it?"

"The war ended forty years ago."

"So?"

"They lost and we won."

"You bet we did."

"They've rebuilt and we're still making excuses. Won't that make them think we're incompetent? And maybe a bit manipulative?"

"I don't care what those Nazis think," Eugene snapped. "Do you want the job or not? If so, stop asking dumb questions and go memorize what I wrote for tomorrow."

I went home and rewrote the tour, taking out many myths and exaggerations. I removed an implausible story where the Germans stole our land by scraping the fertile topsoil and shipping entire

fields by trains into Germany, which was why our collective farms still couldn't bring up the crop production to prewar levels. However, my skills were too limited to write my own tour, and I couldn't just stay silent for the entire three hours. I grudgingly kept the bulk of Eugene's version, but I believed my edits would make me sound less like a prosecutor at the Nuremberg Trial while pointing at courtroom exhibits through the bus window.

In the morning, six tour buses of various models and states of disrepair waited for the Germans at the river port. The six tour guides, five girls and myself, received final instructions from Eugene, who told us who was assigned to which bus.

The German tourists had already taken their places and were waiting for me. A sudden vibration from the ignition raised a cloud of dust from under their seats. Lit up by the morning sun, the dust swarmed over the floor like a smoke grenade. The tourists laughed and clapped hands. Feeling chatty and cheerful, they immediately asked me to say something about myself.

I said I studied languages but also wanted to be an artist. They offered to buy some of my artwork and I made up a lie that I'd sent it away for an exhibition. The truth was that if I were caught selling anything or even accepting money from foreigners, I'd be interrogated by the KGB, my tour guide days would be finished, and there might be other consequences. But telling them the truth would be just as bad, if not worse.

The tour began with me tumbling off the broken tour guide seat onto the bus floor. This time the only person who laughed was the driver. He knew the seat was busted and couldn't wait for someone to

take a fall, hoping it would be one of the girls. The idea of getting it fixed or warning me about the hazard hadn't crossed his mind. I ended up talking into the microphone while standing by the front door, holding on to the railing and struggling to keep my balance as the wheels bashed through innumerable potholes.

I began by pointing at the river port building. According to Eugene, the only thing of interest about it was that it had been destroyed by Germany during the war. From that starting point the tour went into more detail of how many of our soldiers the Germans had killed during the river crossing, as well as the total number of people they'd killed in our area, which still was a tiny fraction compared to the twenty million Soviets they'd killed overall. The economic destruction at the hands of the Germans was just as colossal. All this time a loose microphone wire was causing a merciless crackling inside the bus speakers.

The bus slowed down by the state drama theater, marking the time when I could take a break from the war and recite Eugene's text about the achievements in our culture under the caring guidance of the Communist Party with Dear Comrade Leonid Brezhnev as its leader.

Soon we passed the downtown hotel with the Intourist office inside. I told them that this was the biggest and oldest hotel in our city, and that during the war it was destroyed by Germans.

The tourists asked me what the hotel's name was, pointing at rusty Cyrillic letters on the hotel's roof that were supported by iron beams. The letters said "Our goal is communism," I explained, but that wasn't the name of the hotel.

I noticed Eugene outside, smoking a cigarette and watching our bus. He was just another apparatchik in a suit. What in the world made me think he was cool?

We approached an old sugar factory with a large sign over the roof that said "Long live work," and I wasn't sure how to translate that. At this point of the tour I was supposed to say that Germans had burned down this sugar factory, and from there move to blaming Germany for our failing agriculture.

The crackling was getting worse by the minute. Finally the wire came out of the microphone and the speakers went dead. Without the speakers my voice stood no chance against the loud rattling noise of the engine, combined with some knocking and squeaking and pothole bashing. From then on, I was only pointing at various landmarks and screaming out their names, without having to explain how guilty our German guests needed to feel about them.

At the end of the trip one of them stepped out of the bus and asked me with a sympathetic smile, "Did the Germans also break your microphone?"

When I later came to collect my pay, the Intourist office windows no longer opened to exotic and promising landscapes. All I saw outside was a boring provincial square with a baldheaded Lenin statue in the middle of it, and a huge portrait of Leonid Brezhnev over the post office. I remembered the rusty letters on the hotel roof saying, "Our goal is communism." The aura of adventure was gone.

10

A month before my graduation Anastasia, whom I had hopelessly loved and lost, found me again. Her athlete husband had never become a star; instead, he'd become an abuser and a drunken philanderer. She divorced him and came back to say that she still loved me. Fearing to lose her again, I proposed marriage and she accepted. We were hoping for a bright future, except we had no idea what it would be and how we would get there.

This was in 1983. Leonid Brezhnev had recently died, and our newly appointed leader Yuri Andropov, the former head of the KGB, promised to restore pure socialism by cracking down on sloth and corruption. He started with detaining people in movie theaters for slacking off during work hours. The admirers of Stalin cheered him on; others feared the return of the gulag.

Anastasia and I wanted to celebrate our reunion away from our parents. I suggested we spend a night at the hotel named "Our goal is communism." She laughed at my joke and told me one of her own: "What is the sum of a dark past and a bright future? A gloomy present."

Once we stepped into the hotel lobby, I went straight to the registration, hoping not to run into the Intourist staff. The middle-aged hotel clerk with scruffy gray hair was one of those women who'd stopped caring about their looks the day she got married.

"All single rooms have been reserved," she said. "Shared rooms for six or eight residents are cheaper, but they are for either men or women, so you'll have to sleep separately." She examined us through her thick glasses with the air of superiority that comes with the power of a bureaucrat over mere mortals. It made me feel like an insect pinned under a microscope.

"Can I book one of those six-bed rooms for the two of us?" I suggested.

The clerk asked for our passports and went straight to our *propiska* stamps.

"You have local *propiskas*," she said. "You can't stay here."

"Why not?"

"Hotels are for out-of-towners. If you have the local propiska, you should have a home where you must sleep. If all locals decide to sleep in hotels, where do you propose we put the important people who travel on government business?"

"If hotels are built for out-of-towners, only the out-of-towners should sleep in hotels," I said. "The state quota on rooms makes total sense. Building

more hotels is too petty and bourgeois. Our goal is much bigger."

"What are you trying to say?" the clerk frowned.

"What the sign over your roof says," I pointed at the ceiling.

"We just moved to another city and came back to pick up a few things," Anastasia interfered with a clumsy lie.

"Then your local *propiska* must be revoked," the clerk said. "You can't have it if you no longer live here."

"Please?" Anastasia mustered her most lovable face.

The clerk leafed through our passports again. "I don't see any marriage stamps either. You two aren't married, are you?"

"We are about to get married," I said.

"About doesn't count. Come back when you get a marriage stamp in your passport on page eleven, with the date and location, and your spouse's full name spelled out. I'll be waiting with optimism. And if the name in her passport matches the name on the marriage stamp in yours and vice versa, we'll talk. Until then we can't allow unmarried couples in one room. This isn't a whorehouse."

"Are you calling me a whore?" Anastasia's face turned bright pink.

"If you have a real job, then why aren't you at work in the middle of a workday? Do you want me to call the police and find out?"

"We don't have jobs," I said.

"And yet you have money to sleep in a hotel? There's no place in this country for parasites. Go away, or I'll call the police."

We walked back to my house.

"She's right," Anastasia said. "There's no place in this country for us. And no opportunities either, not

without connected parents. I think our entire country is like this crappy hotel with shared rooms. Citizens are like tenants at the mercy of the management. We own no property here, we have no rights, and the concierge is telling us what we can and cannot do, where and with whom we can or cannot sleep."

"Welcome to the Hotel USSR," I said. "You can check out any time you like, but you can never leave."

"Like Hotel California?" she scoffed. "I wish we had their problems. We aren't even allowed to check out."

"In English 'check out' has many meanings," I said. "We can check out of reality by drinking vodka, which is exactly what most people are doing here, since no one is allowed to leave."

"Welcome to the Hotel USSR then," she agreed. "We were born into this trap and we're going to die in it."

I shared her views on traps, but I believed that my manly duty was to cheer her up. "It can't be that bad," I said.

She stared at me as if I had a hammer and sickle pinned to my forehead. "Always an optimist, aren't you? Weren't you just taught a lesson in Soviet optimism? Our goal is communism and our future is bright, sure! Do you even know what you'll do for a living after we get married, besides drawing your pictures?"

"Something will turn up," I said.

"Something? And what will my life be like with that something? What if they take you into the army for one and a half years? They've just bumped the service for college graduates because of their moronic war in Afghanistan. What will I do then? We have no jobs, no money, and no place to live. Getting married right away was a stupid idea. We must wait until one of us gets some footing."

She had a point. With so many uncertainties, our marriage would have to wait.

The first uncertainty was the army. I couldn't be drafted until I'd fulfilled my obligation to the state and worked for three years in a village school, but Anastasia hated the idea of living in a remote village for three years, only to see me drafted right afterwards. And even if I were to be spared Afghanistan, by the time we'd finally be free to start a new life we'd both be close to thirty, with no jobs, nor money or a place to call our own.

At a time when many sought to avoid the draft, our objective had become the exact opposite: to find a way to get drafted as soon as possible. If I didn't show up for work in the village, the deferment would still apply, and the dean would make sure that no one in our city give me a job. Moving to another city was impossible because of the *propiska*.

There was only one place in the entire USSR where one could freely move in and out without the hassle of the *propiska*, find a well-paying job, and not face too many questions from the authorities. It was called West Siberia. Underneath its eternally frozen swamps was plenty of oil, which the state craved to subsidize its arms race against the West. As long as people agreed to work in that dreary climate, the state was willing to pay double and triple wages, build more housing, and turn a blind eye on our past transgressions.

Anastasia and I devised a brilliant plan. That summer, right after getting my diploma, I would run away to Siberia without telling anyone, find any temporary job, register at the local military commissariat, and wait a month or two for the fall

draft. Since Anastasia had no telephone, we would write each other letters.

On our last day together I drew a sketch of her taking a nap in her bed and later turned it into a painting of her dreams about our future together, which we still hoped would be colorful, bright, and vibrant.

11

I settled in a small Siberian town, found work with a road construction company, and showed up at the local commissariat to provide them with my new address. My job was to repair the roads that connected the town with the oil fields. Whenever the topsoil didn't stay frozen, the roads quickly sank into the bog, no matter how much sand we shoveled underneath the reinforced concrete slabs.

Our three-man crew traveled along these causeways inside a mobile crane under a never ending drizzle of rain. We would find cracked and warped slabs, extract them using the crane, and replace them with new ones, which we knew wouldn't last long. Once in a while, I saw half-submerged trucks and tractors in the nearby swamps. It was probably easier to abandon them there than to pull them out.

In late September freezing winds from the north turned the non-stop drizzle into a non-stop dry snow that wouldn't melt until May. One day, halfway to the oil rig, I was shoveling an especially large pile of sand. My sheepskin coat felt like a hot oven; I threw the coat on the snow and continued to work, enjoying the refreshing cold wind on my spine. Minutes later I collapsed on the ground with excruciating back muscle cramps. The crew carried me to the crane and at the end of the shift drove me home. The town doctor diagnosed me with lumbago caused by ignorance and stupidity: never expose your sweaty behind to the frosty wind. The draft notice came in the mail on the following day. Unable to walk, I replied to it with a doctor's note. The next draft would not be until the following spring.

I sent Anastasia a letter explaining that our marriage had been postponed by six more months, and asked if she wanted to visit me. With a two-week delivery time, her response came a month later. She was unhappy but hopeful that nothing that stupid would happen during the next draft. My invitation to visit caught her off guard; she had no plans to travel to Siberia in wintertime. I got myself another job and spent that winter alone. I

worked, read books, painted pictures, and waited for spring.

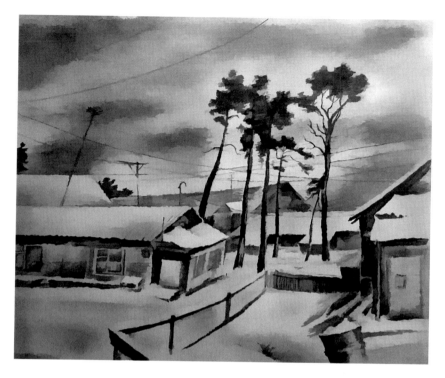

The spring draft went without a glitch. My group of several dozen conscripts from nearby towns were herded into a train car and shipped a thousand kilometers to the south. Our final stop was Tumen, the administrative center for all of West Siberia. The climate there was a lot warmer; I might as well have been back in Ukraine. The train car attendant made sure we had plenty of vodka, charging double price for the bottles. That made the whole thing feel like a faster trip. At the military compound in Tumen, however, things slowed to a halt.

That year West Siberia had attracted more young men of conscription age than the regional command could absorb. We lived in army barracks, waiting for the arriving enlistment officers to split us apart and

take us away. Everyone called them "buyers," which made me feel like a slave on a market. The "buyers" were more interested in the 18-year-olds. Five days later, after all the youngsters had been "purchased," about a dozen of us still remained, mostly college graduates. We kept wandering aimlessly about the large military compound day after day, feeling abandoned.

Unwilling to acknowledge the overdraft, the command set up a new medical commission tasked with finding excuses to send the leftovers back home. I was in excellent health; the only physical flaw they could find with me was *tinea pedis*, commonly known as athlete's foot, the result of wearing heavy felt boots from morning till night throughout the long winter. I was ordered to report for treatment at the Hospital for Skin and Venereal Diseases in the city of Surgut, which was near my oil town up north. I picked up my things and headed back into the winter.

No one at the Hospital for Skin and Venereal Diseases believed my story. Patients with syphilis laughed at the notion that athlete's foot could result in a deferment. The chief physician, a belligerent middle-aged woman with a Stalinist streak, accused me of trying to dodge the draft. She called me a deserter from the army and promised to make my three-week treatment as rotten as possible. Her put-downs meant nothing compared to the depressing prospect of breaking the news to Anastasia. My painting of her beautiful dreams flickered before my eyes. The last thing I wanted was to inform my fiancé about another deferment from the Hospital for Skin and Venereal Diseases.

Several dozen patients infected with various diseases lived, about ten people per room, on the second floor of a wooden two-story building. Two rooms were for women and the rest were for men. The first floor was the reception area with all the doctors' offices. A wide stairwell between the floors was a smoking area that doubled as a social club.

My roommate with a bad case of psoriasis had a guitar. We became fast friends and soon I was playing songs that my friends and I used to sing at home. I started with the Beatles' In My Life. The men in the room awarded me with blank stares. They'd expected some popular Russian tune, but I never cared for the songs that rotated on the state-run radio channels. I broke off in the middle and started Blue Suede Shoes.

Suddenly the door swung open and the chief physician ran inside, waving her hands and screaming at me in a high-pitched voice.

"What kind of an enemy provocateur are you?" she demanded. "Deserting the army wasn't enough, now you want to corrupt my patients with subversive music?"

"It's just a humorous song," I said, passing the guitar back to its owner.

"It's in a foreign language," she argued. "For all I know, it can be insulting our country and our way of life."

"Funny you'd mention our way of life," I said. "You're got rooms full of perverts, gang-bangers, and whores, but I'm the enemy of the people here? Afraid that my athlete's foot would offend their syphilis?"

"Syphilis can be cured, but your fungi is forever," she said with an angry cackle. "It will spread to your

[error]

I made friends with an aging alcoholic woman, who had wasted her youth on parties and men, and was brought to the hospital by the police bearing a venereal disease and two black eyes. Being childless, she spent most of her time knitting cute baby shoes for other people's children. She was simple and sweet but also filled with deep sadness. I imagined that her incessant knitting was her way to block the emptiness she was facing as she grew older and less appealing to men. She was damaged goods, too; we had that in common. My own incessant drawing was probably also my way to avoid thinking about the uncertain future and to stop feeling the emptiness that was beginning to grow in my heart.

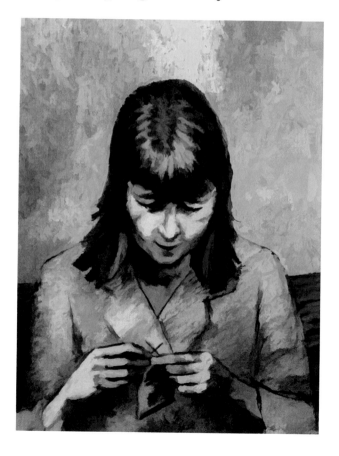

Since I had ink but no ink pens, I improvised a technique of drawing with matchsticks and smudging occasional lines with my fingers. Luckily for me, all Soviet matches were made out of wood and almost everyone was a smoker.

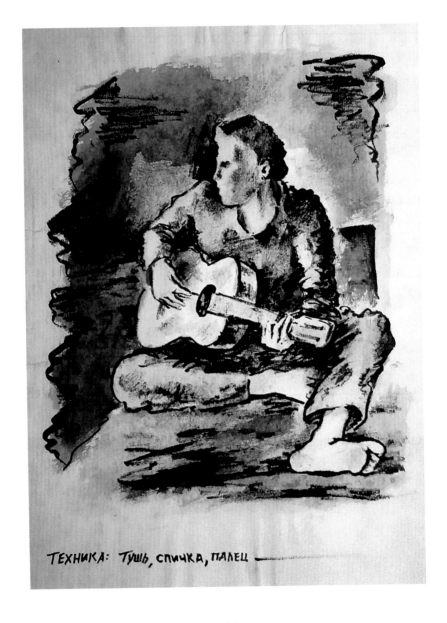

ТЕХНИКА: *Тушь, спичка, палец*

A patient named Pavka looked like a hero from an old Soviet movie: an earnest and selfless fighter for social justice. Even his disease was social. Smudging two colors of ink with my fingers, I stylized his portrait to look like an early Soviet poster.

Sasha always expected me to say something funny and was ready to laugh even when I didn't mean it. Somehow he managed to make me feel better about myself. I tried to capture his flamboyant, colorful character in a quick off-beat sketch.

There was a tight group of six thugs covered in prison tattoos: diamonds, stars, crosses, medals, and Orthodox churches. They had all contracted syphilis simultaneously from the same twenty-year-old woman who was there for treatment, too. The thugs would sometimes lock themselves up with her

in an empty room, leaving a guard by the door - a weakling whom they terrorized into following them around and doing their bidding. He never had sex with the woman and only became infected because they had forced him to lick her body after they were finished.

One of them had discovered that I was an artist and informed me with an air of great importance that he had a tattoo of the Siptim Madonna on his chest.

"Is that by any chance the Sistine Madonna by Raphael?" I asked.

"No, it's the Siptim Madonna."

"Are you sure?"

"I said what I said," he sounded offended. "I should know, I've had it for years."

He unbuttoned his hospital robe to show me a large, trashy tattoo of some generic Madonna with Child that began at his nipples and ended below the belt line. It looked nothing like the Sistine Madonna. Her small hand, drawn over his deep belly button, looked disfigured, as if it had been stabbed with an ice axe. I'd heard that a tattooed Madonna symbolized a criminal lifestyle from a young age and was an allusion to the Russian phrase, "prison is my dear mother." This wasn't an opportune moment to discuss fine arts, so I nodded and said, "Nice Siptim Madonna."

His comrades soon spotted me drawing in black ink and figured it was tattoo time. They stole my ink, then they ripped a string from my friend's guitar, and extorted an electric shaver from an old man from another room. They took off the shaver head, attached the guitar string to the moving mechanism, wrapped its other end into a cotton thread, placed it

inside a hollowed plastic pen, and dipped the tip into my ink bottle. When they turned on the shaver, the ink-stained tip of the string began to move rapidly in an out of the plastic pen, making it a makeshift tattoo machine.

With much of their skin already tattooed, they were filling available spaces with simple crosses and stars. At one point they suggested that since I was an artist, I could draw more complex things like eagles and snakes on their skin with a ballpoint pen, so they could go over my lines with their machine. I refused on principle. To my surprise, they respected my choice and never asked me again. Perhaps, the doctor's harassment had raised my status in their eyes to that of a rebel and a kindred spirit. There was no more ink drawing or guitar playing.

One evening I offered to draw a portrait of a fidgety man who I'd noticed would always get nervous when he saw me draw other people. He agreed but refused to stand still, changing his position every five seconds. I gave up on the portrait and made a quick character sketch instead. He looked at the result and said nothing. I thanked him, turned over the page in my sketchbook, and started another drawing.

Suddenly the fidgety man began shouting. "You think you're an artist? You think you can draw?" His hostility strengthened with every word. "I used to draw like that, too, only better. But then I grew up. I shat all that stupid art out of my system. You'll grow up, too, and then you'll find out. There's no point in any of it."

The more he talked, the angrier he became, as though some long-suppressed emotions had found a breach and rushed to the surface like a volcano. I

half-expected him to jump at me and was readying myself for a possible fistfight. But instead of attacking me, he suddenly ran out into the hallway and down the stairwell. Soon we heard loud repeated banging echoing throughout the hushed hospital. It appeared that he was trying to break the locked door to the closet that held our street clothes. A scared nurse called the police. The rest of us exchanged uncomfortable looks. He finally broke through the door, grabbed his coat, and rushed to the exit. The police was already waiting outside. They drove him away into the snowy night and I never saw him again.

After three weeks in the hospital I returned to the oil town that had become my new home.

12

Six months earlier, when my back cramps had ended my sand-shoveling career, I found out that the same company was looking for a graphic artist to handle their visual agitation and propaganda. The previous guy had made enough money and moved back to the mainland, so I told the management I was an artist, too. One of the few good things about West Siberia was that official paperwork was not as important as the ability to do the job. All I had to do now was to prove I was telling the truth.

The pay was smaller than in road repair, but about three times higher than if I were a teacher on the mainland. My new workshop was just a room in a wooden barrack that held several one-room apartments for the workers, two blocks away from the company office. There was no inside plumbing; people from the surrounding barracks shared one communal latrine and stored their drinking water in buckets.

When my neighbor behind the thin plywood wall found out that I was an artist, he immediately offered me partnership in forging passports and other documents, saying he knew a lot of potential clients. I laughed it off. He called me a sissy and never spoke to me again. With Siberia being the land of prison camps, many ex-convicts who had nowhere to go upon their release, stayed and worked in these oil towns.

Just like the typical American landscape is dotted with billboards advertising products and services, the typical Soviet landscape was dotted with state propaganda calling on everyone to struggle for the fulfillment the Five-Year Plan, struggle for the improvement of our collective well-being, or struggle

for the betterment of our culture or education. Such billboards were often the only bright spots of color and clean design in the otherwise drab landscapes. Sometimes they were just simple slogans: "Long live work," "Long live the Party," or "Long live our socialist Motherland."

Visual agitation and propaganda, or agitprop in the Soviet Newspeak, had two aspects: motivational and political. The intent was to motivate people to work harder, given that miniscule wages motivated no one, and compulsion through terror had gone out of vogue after the death of Stalin. Politically, it was also meant to inform us of our unanimous support for the Party and its leaders, inspire confidence in socialism, and hasten the unstoppable march towards communism. Conformity and compliance was the real, unspoken objective.

Being the only game in town, however, omnipresent propaganda had lost its edge and turned into background noise. If everyone is a communist, no one is.

All children were Little Octobrists and then Young Pioneers, blasphemously wiping their noses on each other's red scarves. From fourteen and into their twenties they were all card-carrying Young Communist League members just so that the teachers wouldn't nag them and because membership was required to get into college. All students wrote essays on Marxism and quoted Party leaders, just so they could get good grades and a diploma. People of all ages ritualistically marched in May Day parades and carried pre-printed signs without reading them. Most of us used these fresh air parades to work up our appetite before the traditional drinking parties rather than to express solidarity with the world's workers' parties.

By the mid-eighties, agitprop had similarly become a mindless ritual. Propaganda was to the state what a pair of pants was to a man when he showed up in public; all men wore them to preserve their dignity and cover up shameful parts. It was as normal and necessary as a dress on a woman, a different one for every occasion or weather. Likewise, agitprop posters had become meaningless traditional ornaments, similar to how the Madonna and crosses had become prison tattoos with entirely different implications.

Visual agitprop was also a job that fed an entire class of low-level graphic designers who might have preferred commercial advertising, but in the absence of such they worked off the templates created by higher-level members of the Artists Union. Since centrally designed agitprop couldn't cover all local issues, larger companies employed one or more of these artists to make hand-written signs, announcements, motivational slogans, and hall-of-fame displays with photos of the best workers who fulfilled their quotas.

My first assignment was to paint a bunch of hand-made road signs because the supply of real signs with reflective film was insufficient. The supply of paint, I found out, was also sketchy. In addition to a few cans of oil-based construction paint, my boss told me I could have a large steel barrel of toxic, acetone-based blue paint that was of no use to the construction workers after someone had left it outdoors in minus forty degrees weather and it had frozen into a solid block. I rolled the barrel into my workshop and left it in the corner to melt. This room would also become a base for my personal art projects.

My boss's job title was Party Organizer, abbreviated as "partorg." Contrary to what the title suggests in English, he was really a political commissar upholding the invisible Party line in the organization. Every Soviet company had a partorg.

Apart from giving me work assignments, his job was to organize company-wide meetings, political education workshops, and lectures that enlightened us about what was really happening in the world. He

invited guest speakers from the Knowledge Society, who provided the Siberian road workers and crane operators with the most correct opinions about current events, which always included denunciations of Ronald Reagan and his imperialist policies. Partorg also advised the company director while making business decisions or handling work-related crises. In short, he was a secular priest conducting sermons, confessions, and political exorcism.

He and I worked from his book of pre-approved posters, slogans, and other agitprop elements. Printed in a coffee table book format, it had been developed by the Department of Propaganda in Moscow as a guide to local partorgs and designers. I called it the "propaganda bible." My boss preferred that I'd simply copy existing designs. That way he took no political risks and it made my job easier. We would sit in his office, go through the pages of his catalog, and discuss what we could do with our limited resources.

By January, I had proved my skills by producing a few large posters and handwritten signs, as well as New Year's decorations in the company lobby. The latter included a Soviet version of Santa Claus who encouraged the employees to struggle for greater economic achievements and bring glory to the Motherland. New Year's Eve was the least political day of the year and, therefore, everyone's favorite state holiday, celebrated over several days with nonstop drinking and eating of favorite foods. Once everybody had sobered up, my boss called me to discuss a major project: the replacement of a large Brezhnev billboard that stood in the main street between two residential barracks, strategically blocking the view of the communal latrine in the back.

Brezhnev had been dead for two years, but portraits with his unusually gaudy eyebrows still hung on every street corner and office wall. Since I was little I remembered him being constantly praised as our Dear Comrade General Secretary. Teachers made us write essays about our appreciation of his endless, monotonous speeches. All TV channels showed long ceremonies in which he was awarded one or another medal for his alleged achievements, and artists were required to paint those additional medals onto his portraits. When the number of these decorations passed the point where he'd be able to walk upright, the visual propaganda protocol was adjusted. The minimum required quantity of newly painted medals was reduced to the nation's highest award, Hero of the Soviet Union, in the form of a gold star suspended from a red ribbon. Every time he received a new gold star, artists simply updated existing portraits by adding another to his chest.

That strategy backfired when, by the end of Brezhnev's rule, they ran out of chest space. The first two stars looked great, but the third star already went over his left sleeve. When our leader received his fourth star, his portraits had to be taken down for shoulder extensions. More thorough artists added shoulders on both sides for symmetry; lazier ones extended only the left shoulder enough for a four-star upgrade, and called it a day. On our billboard the left shoulder was longer than his right one. To the relief of the artistic community, Brezhnev died with only four stars.

His successor, Yuri Andropov, promised hard-line reforms, but he was a sickly old man and everyone just waited for him to die. No one knew who our next leader would be; but it was known that he would

come from the highest ruling body, the twelve-member Politburo of the Communist Party, and each one of those twelve was just as sickly and old. Jokers popularized the word "gerontocracy," rule by old people, as a proper description of our form of government. Pending the new leader's appointment, local officials abstained from doing any reforms that could backfire on them later. The wisest policy was to wait and do nothing.

That also described the Propaganda Department in Moscow. Developing strategies to promote short-lived reforms, or creating a new personality cult for a dying Andropov seemed like a waste of time. They still hung onto Brezhnev's copious portraiture for two years after his death, but not because they missed him; it's just that ditching him too soon could make their next project less credible (and in some cases expose the latrine). In private they laughed at Brezhnev jokes as much as everyone else did, probably realizing how much their over-the-top propaganda had contributed to those gags. If someone were to compile all Brezhnev jokes into a book, it would've had more pages than the nine-volume edition of Brezhnev's speeches, titled *Following Lenin's Course*, that stood on my boss's bookshelf, never opened.

When I entered the boss's office, he was leafing through the propaganda bible.

"It's time to replace the Brezhnev billboard," he said. "Keep the frame, just paint something new."

"What's the new concept?"

"I have no idea. I want something current." He stared at his catalog, looking lost.

"An Andropov poster?"

"No, I'd like something we won't have to redo next year." He turned over a few more pages. "All these designs seem suddenly out of date."

"No timeless messages in that bible?"

"A message for the ages?" the partorg rubbed his chin. "I know! We'll do a poster of Lenin. He's the father of our revolution, he created the USSR. That will never change."

His catalog had a classic poster of Lenin raising his hand. The caption, "Following Lenin's course," nicely echoed the title of Brezhnev's speeches. However, I objected to the solid red background that looked like a waving flag.

"My only can of red paint is nearly empty," I said. "But we have an entire barrel of melted blue paint."

My boss agreed that beggars can't be choosers and approved the blue background instead of a red one.

The billboard was made of plywood nailed to a six by nine foot wooden frame. In the evening the company workers took it down and left it lying on top of a snowdrift outside my workshop. In the morning it started to snow. The blue nitro paint was too toxic to use indoors, so I repainted the billboard where I found it. Using the snowdrift as a workbench, I swept as much snow from Brezhnev's portrait as I could with my mitten, and applied a shiny new coat of paint with a roller. In spite of the cold the acetone-based paint dried very fast, even when mixed with the falling snowflakes. The following day I dragged it into my workshop and started to copy the Lenin poster from my boss's catalog.

I recalled my schoolteacher's warning that unauthorized drawings of Lenin could lead to

consequences, and how it was an exclusive privilege that the Party and the state granted to the best artists. It made me laugh. My boss was the Party and the state in one person; he gave me an authorization, so damn the consequences.

When I finished it a few days later, the billboard looked reasonably decent. The only difference with the original was that Lenin was executed in alternative colors to match the new background, which instead of a waving red flag looked like a freshly painted blue wall. It was as if the father of the revolution was inviting his followers to line up against that wall, under the caption, "Following Lenin's course." The workers mounted it back on the wooden pillars without any objections.

A few weeks went by and the blue paint began to crack, looking worse with every passing day. The cracks started to peel and splinter into flakes, which fluttered off the surface onto the snow below like leaves off a dying tree. My guess was that the earlier freeze might have changed the paint's properties, and applying it on an icy surface in the falling snow didn't help either. By the end of March my Lenin looked like a disheveled bum with a ghastly cracked face.

As if that weren't enough, Brezhnev reemerged through the cracks, blue in the face and glaring from under his freakishly huge eyebrows. These partially overlapping semi-transparent figures now looked like two ghosts from our communist past, extending their hands and attempting to grab us. The billboard began to look like a portal to the netherworld gulag through which dead communist leaders communed with the living, trying to lure us into their world, under the caption, "Following Lenin's course."

The transformation of our leaders into zombies went largely unnoticed, confirming my theory that propaganda art had lost all meaning other than being an accent of color in a colorless world. I wish I had taken a photo of it, but even if I had, it wouldn't be in color.

I was paid a flat salary regardless of the quality of my work. If the state didn't allow me to be a real artist, I might as well earn money churning out lousy posters. Even if I were an Artists Union member, I'd be doing the same thing but with added pretence. I wondered what would come next, a drinking habit? Was I growing into a replica of my degenerate tutor? The thought was depressing. On the other hand, I was only biding my time here. In a month or two I'd be in the army, and whatever happened after that, I'd still have the money I'd saved thanks to the lofty Siberian wages.

The creepy billboard didn't last long; it burned down along with the outhouse behind it. The cause of the fire was obvious to everyone involved. The wooden latrine had two gender sections with separate entrances, each with six round holes in the wooden floor and without any partitions or stalls except for the dividing wall between the gentlemen and the ladies. In the warm months, the holes in the floor offered the view of a void filled with human and kitchen waste. By mid-winter the holes froze up and the waste began to pile up on the floor in the form of an icy mountain range that would have resembled the Himalayas if these peaks were white. Men and women in the surrounding barracks complained that they needed an ice axe and climbing ropes just to relieve themselves. The company management didn't care until one night someone poured kerosene on the mountains of waste and set them ablaze.

Once this had become a legitimate crisis, our company dropped other construction projects and quickly built a better equipped, heated structure. The neighbors stayed mum about who might've done it, each of them probably wishing they'd done it sooner. I suspected the arsonist had also splashed some kerosene over Lenin and Brezhnev for good measure. The damaged billboard was the least of anyone's worries; it ended up in a pile of outhouse debris and later shared the same garbage dump.

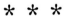

The winter days were short. The cold, small sun always hung at the horizon. By three o'clock it was sunset and by four it got dark. No matter how warm I dressed, sitting outside without movement was dangerous.

Sometimes I squinted my eyes at the setting sun and imagined, just like I did as a child, that this wasn't Siberia with thousands of miles of white snow around me. What I saw was white sand on an Atlantic beach with a red evening sun blasting its rays through a hot coastal haze. Those weren't frozen Siberian pines but lush tropical palm trees, and it felt cold only because I'd just come out of the water; soon enough I'd be warm again and craving to dive back into the brisk salty waves.

I had no idea where to place that landscape, but I wanted it to be in America. I imagined it to be Florida with its palm trees, white sandy beaches, humid haze, and romantic sunsets. Years later that vision had become my reality and I'm now living

among those tropical palm trees in Florida. I still resent even having ice in my drinks - perhaps out of a subliminal fear that the ice will destroy this illusion and I'll wake up back in Siberia, squinting at the cold setting sun amid miles of white snow and frozen pine trees.

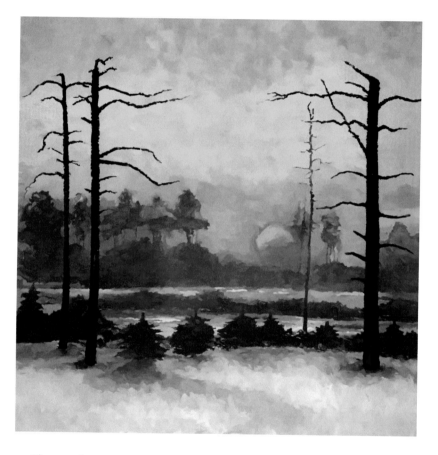

I'm always surprised at the reverence many American artists have for the old Soviet posters. They jeer at commercial art, while they cheer agitprop of a totalitarian state. Most Soviets took it with irony and contempt. It boggles my mind that so many in the free world can admire propaganda of tyrannical sociopaths, corrupt bureaucracy, and a

perverse regime that stomped out humanity. How can a free artist admire a despotic establishment?

I guess creative people sometimes have the need to squint their eyes and imagine themselves in a different world. While I wished I were in America, some American artists wished they could do agitprop in a people's state of their dreams. But these wishes are not interchangeable. The free world always lets us to move in and out, but the world of their wishes may not be as kind as they think, and if they will it into existence, it may never let them go back.

Be careful what you wish for.

13

The spring draft brought no relief. As mentioned earlier, it ended up with two weeks at the Tumen military compound, followed by three more weeks at the Surgut Hospital for Skin and Venereal Diseases.

I worked through the summer to make up for the five-week absence. Now the sun refused to go down until midnight. Falling asleep with full daylight was tricky, but longer days also allowed me to stay out late with my brushes and paints. The sun would get hot enough for some town residents to sunbathe on a sandy beach by the river, which the local tribe of reindeer people called Ingu-Yagun. Its water was ice-cold, as a reminder that this winding river, the warm beach sand, and the town itself, existed on top of a colossal block of ice that had stood frozen for thousands of years.

One couldn't undress on the beach without using insect repellant. I hadn't seen bug sprays before I came to Siberia. They weren't for sale, but local

companies distributed them freely, along with head nets, to protect their workers from bites. The worst were the tiny flesh-eating flies. They would take a bite off my skin and leave a dent that would itch for weeks, and too many of their bites could lead to blood poisoning. Everyone knew a recent story about two college students who had come to our town for a summer job. On their first night they got drunk and fell asleep in the woods not far from their barrack. Back at home they would've awakened with a headache; here they were found dead in the morning, their faces and hands covered with hundreds of bites.

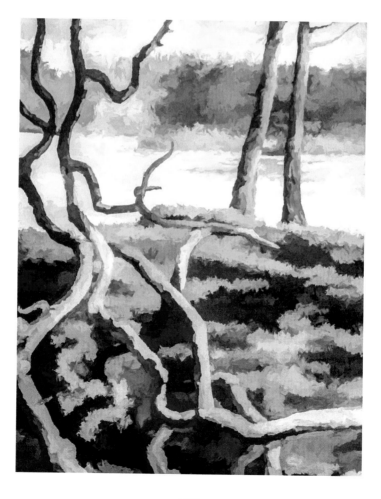

One day I set up my easel in a picturesque spot by a swamp and realized I'd forgotten to bring my bug spray. I was immediately surrounded by mosquitoes. My initial plan to keep swatting them had been too optimistic. With reinforcements arriving every second, the swarm quickly became a buzzing cloud, so dense that I could barely see the easel in front of me. I was about to admit my defeat, pack my things, and run home.

Then I saw a team of geologists passing by in their military-style armored carrier on steel tracks that allowed them to go through this flat terrain in a straight line without slowing down for trees. I flagged them without much hope, but they stopped and opened their port door. I asked if I could use their bug spray on my hands and face. They said that in these swamps one puff might not be enough and gave me an entire large spray can to keep. Then they closed their port and drove off, leaving a straight clear path in their wake.

The company cafeteria served the same bland menu, no matter the season. All their produce came from the mainland because nothing edible grew in these swamps except berries and mushrooms. The latter, however, were in abundance.

Almost everyone went berry-picking or mushroom-hunting in the woods, always carrying bug spray and head nets. People would bring home large backpacks full of mushrooms to be fried with potatoes and onions, or pickled with garlic and dill, or dried in the sun for the winter. One hour in the swamps was usually enough to fill a large bucket with cranberries or sweet lingonberries that were good to eat straight or to make jams.

This diet kept me going for a year, but in the fall my stomach gave up again and I was taken to the hospital for infectious diseases.

14

This hospital was much better than the one in my hometown, but the treatment was exactly the same: brown pills and no explanation as to the cause and prevention. I spent the next three weeks reading books and drawing portraits of other patients.

One of them was a member of the local indigenous tribe. Researchers from Finland and Hungary studied their language and culture, finding similarities to their own. Part of a larger Finno-Ugric family, their genetic makeup was influenced by the Mongols and other Asian invaders. Attacks from the raiders kept pushing their ancestors further and further north, until they found refuge in these harsh frozen lands, without realizing this was one of the world's largest oil reserves. Now that this treasure had been discovered, they still weren't getting the perks because all the land with all its resources belonged to the state.

The tribe's English spelling is Khanty, but it sounds more like "Hunty." One man is a Hunt. That's what everyone called him and he didn't mind. He worked as a tractor driver at some state-run company, but he was also a hunter who could

shoot a squirrel in the eye to spare its fur. Like some of the other Hunts I met in Siberia, he was exceptionally straightforward and honest. Although possessing a deep resounding voice, he didn't speak much. His portrait matches his character: simple and calm.

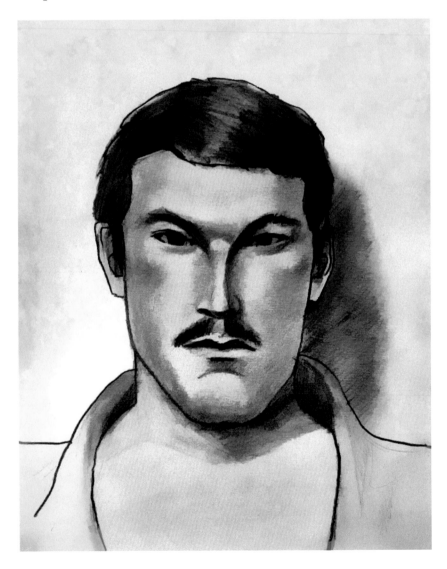

I kept perfecting my method of drawing portraits by smudging lines of ink with my hand. I called it "a poor man's airbrush." This man was a Bashkir - a Turkic-speaking ethnicity of former nomads, now settled on the southern slopes of the Ural Mountains in Russia.

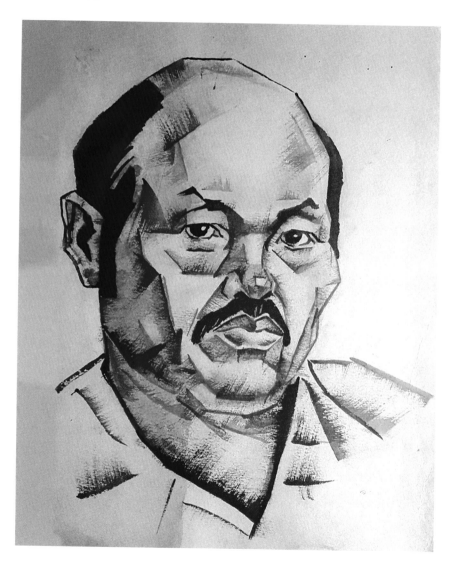

There was a girl whose head had been shaved to get rid of lice. I drew her pupils as piercing black dots to channel the eerie impression of looking her in the eye. Drawing her irises realistically failed to adequately convey that feeling.

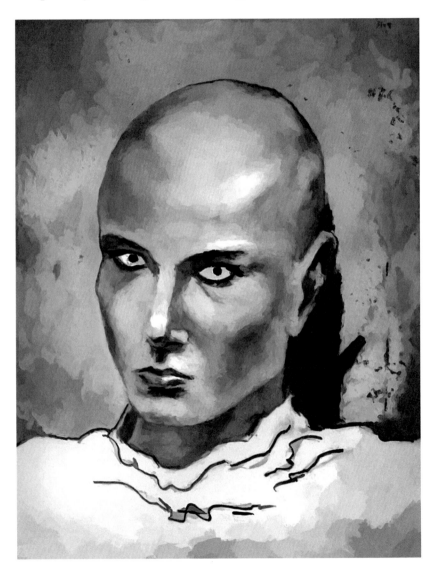

Magomet the Chechen looked fearsome but in
reality he was timid and quiet. He was a truck driver
bringing supplies to the oil rigs. I made several
portraits of him.

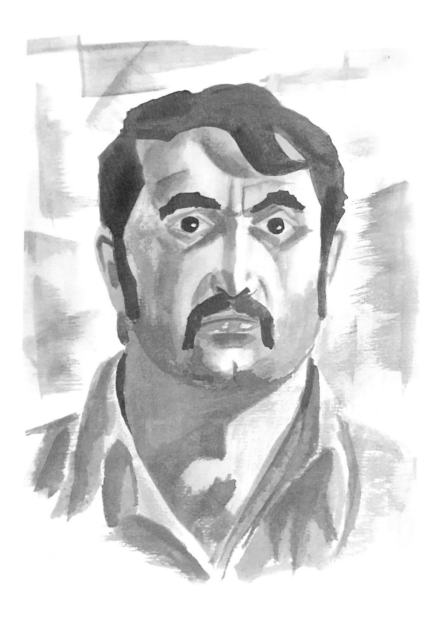

Sarmat the Ossetian reminded me of Italian Renaissance drawings and that's how I also stylized his picture.

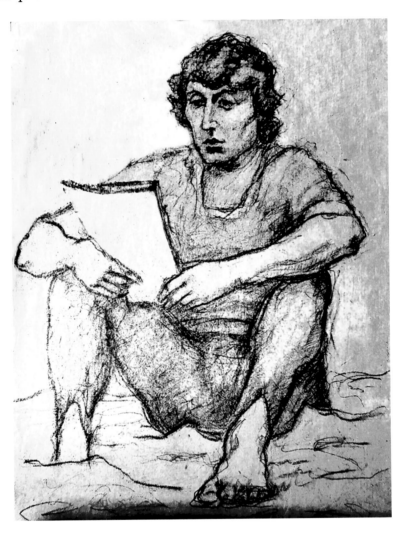

Alexander was a carpenter of German extraction. German colonists had been settling in Russia and Ukraine over several centuries. At the beginning of World War II, Stalin accused their descendents of treason and exiled close to a million of ethnic Germans to Siberia and Central Asia. Alexander was

born in such a family after the war. He didn't speak German but had a German last name. Watching the plethora of Soviet TV shows and war movies that portrayed all Germans as monsters must have been depressing. He was an alcoholic but that didn't affect his excellent chess skills.

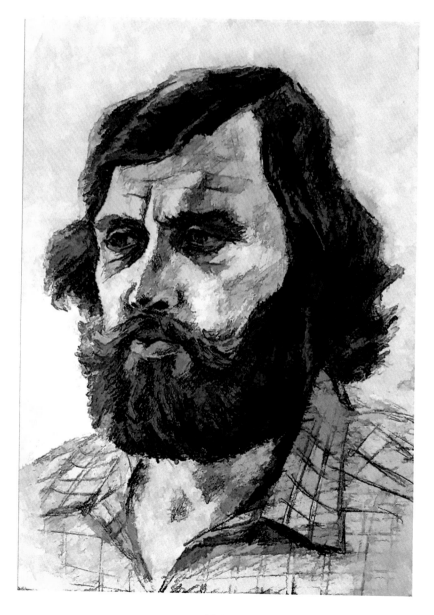

Many others, whose names I cannot recall, also had fascinating faces and characters. The boredom of the hospital turned them into my willing models.

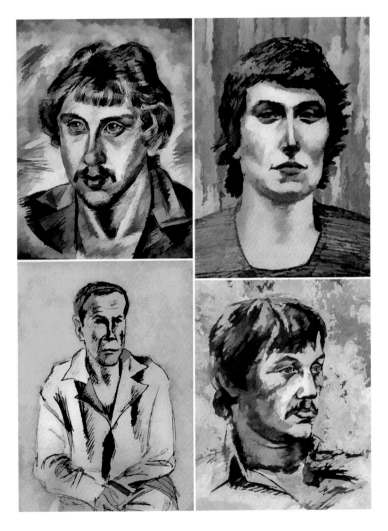

As my luck would have it, this hospital stay coincided with the fall draft. My military service was postponed again, against my will, until the next spring. Prepared to bide my time through another Siberian winter, I returned to my new home.

15

My boss's divorcee daughter took a liking to me and began to stop by my workshop more often than her job as the company accountant required. She wasn't my idea of a dream date, but I was lonely and her presence was comforting. Before things turned heavy and serious, her brother, Igor, paid me a visit. Big and strong, he was protective of his sister and wanted to find out if I was a good match. He had just returned from the army and told me how much he enjoyed his two years of service. He gave me tips on how to handle myself once I'm drafted, confident that I'd also have a great time there as long as I played my cards right. He was passionate about military camaraderie and wished we had more of it in our civilian lives.

One of his tips explained how to retain optimism and good spirits by beating someone up. For example, he found himself a permanent beating boy whom he would kick every time he felt down. He said the weakling deserved it because he pretended to be an intellectual and used big words, even though he was just some ethnic minority known for being dumb. His beating boy complained to an officer and for that he was again beaten. It lasted for a few months and then one time Igor accidentally caught him in the toilet. He hadn't planned on it, but it was too good a chance to let go. Not knowing what to do, Igor hit him in the face a few times and then ordered him to drop his pants. Then he anally raped the boy. He gleefully described every detail of it, and finished with an observation that anal rape was overrated because he didn't enjoy it. Then Igor stopped smiling and added that the boy was an even bigger idiot than

he thought because a few hours later he hung himself. His mother arrived, demanding an investigation, using big words, and also acting as if she were an intellectual, but military camaraderie prevailed. The officers, the soldiers, everybody - just closed ranks and the matter was swept under the rug. Nobody was punished.

When Igor's sister stopped by my workshop later that day, I told her that I had a woman waiting for me on the mainland and we were planning to get married. I even showed her Anastasia's latest letter, omitting the old postmark date on the envelope. As the words were leaving my mouth I realized how much of a sham that story had become. The lie worked and I never spoke with her or her brother again. Their father the partorg was still my boss but our relationship was strictly professional. At least I no longer felt guilty about taking this man for a ride with my long paid leaves every time I attempted to join the army and wound up in the hospital instead. His company, the army, and the hospitals belonged to the same state and were funded from the same source.

I can't recall if it was Anastasia or me who stopped sending letters. It could be me; I felt guilty about holding up her life and letting her down. To register for the draft and not get drafted was like walking into the water and not getting wet. That made me feel like a loser and a failure. I wonder sometimes where she is now, on which side of the Atlantic or the Equator. She was too ambitious to remain in the USSR after the restrictions on foreign travel were lifted. If it weren't for those restrictions we might've gone to America instead of Siberia. Or maybe not, since neither of us could afford the ticket.

In the middle of that bleak winter I made a nostalgic fantasy picture of a cat staring at a starry summer sky from the roof of my old house in Ukraine. It was where my friend and I used to dream about stars, eat pears from the tree, and read science fiction stories in the company of cats.

I kept making posters and signs for my boss, painting my pictures, and writing. My habit of writing my thoughts into a journal was now developing into something bigger: I started writing short stories. I also started a novel but saved my dignity by never finishing it. I even tried poetry but found out that, apart from comical verses, I couldn't rhyme if my life depended on it.

The military draft no longer made any sense. I'd be six years older than the average conscript.

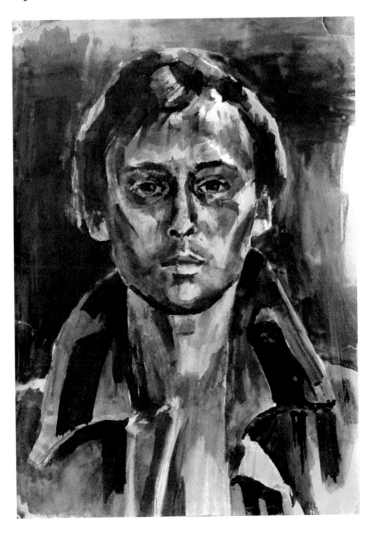

I remembered how the officers treated draftees as if they were livestock, and I doubted I'd take their insults well. The war in Afghanistan was getting hotter, with more and more of our high school graduates being sent to their deaths, all to help a tiny clique of Afghan communists install a Soviet-like regime in those barren mountains. The state-run media suppressed the news of our casualties, but the number of killed and maimed was rumored to be in the thousands. Sacrificing my life for communism would be ludicrous.

Thinking about it, I drew a portrait of myself in a soldier's overcoat. Dark and gloomy was the intention.

16

The spring draft brought me back to Tumen, a thousand kilometers south of my oil town. Still wearing our civilian clothes, we lived in the same military compound and waited for the "buyers" to herd us away.

While still on the train, our group had become polarized. On one side was a thuggish nineteen-year-old with ambitions of a gang leader and a posse made of wannabe bullies and those who would rather side with the bully than to be bullied. The rest of the group gravitated towards me. Whether I wanted it or not, I projected authority just by virtue of being older and more articulate than the rest.

Most of them liked rock music and I was only happy to dig into my memory, translating their favorite songs into Russian and explaining their meaning. One of them asked me about *Smoke on the*

Water by Deep Purple. He told me that he had attended his company's lecture on political education, where a guest speaker from the Knowledge Society claimed the song was a hit piece by the Western war propaganda machine, describing how Russia would go up in smoke. All true, I said, except the song wasn't about Russia, propaganda, or war. I translated some of the lyrics as I remembered them, about how the musicians came out to Montreux on the Lake Geneva shoreline to make records with a mobile studio, but some loser with a flare gun burned the place to the ground. We also talked about the Beatles, Pink Floyd, Queen, and Creedence Clearwater Revival. Our thuggish adversary knew none of these names and ridiculed our conversations as "gay."

His gang's main target was a kid from my group, a blonde gentle giant named Chekhov. Despite his size, he panicked every time he was threatened. This delighted the posse who claimed Chekhov was gay and deserved what was coming. I didn't know if that was true, but even if it were, he was a human being who didn't bother anybody, and I couldn't just watch them denigrate an innocent man in front of me. Our verbal standoffs were on the verge of becoming physical. Afraid to be on his own, Chekhov followed me everywhere I went.

On our third day in Tumen, a "buyer" showed up and rounded up a bunch of "slaves" from among the gang, including the bully himself. They were to pick up their belongings and report to the office in half an hour. I felt like celebrating and went for a walk around the parade ground, smoking a cigarette. With most of the draftees already gone, the compound looked deserted. A few of my new friends

joined me to finish our conversation about Andrew Lloyd Webber's music.

They all liked *Jesus Christ Superstar* but couldn't understand the words. I said it was the story of Jesus retold with humor and in a modern format. They wanted to hear the story. Like me at their age, they'd only known occasional fragments. I told the story as I remembered it: Jesus realized that the system was hypocritical and corrupt, and he thought he could fight it by telling people the truth. Naturally, the authorities hated that. They wanted to get rid of him, but to do so in a way that wouldn't implicate them as despots and murderers, because every ruler wants to appear moral and just in the eyes of the people. They put Jesus in custody and kept transferring him from one government agency to another until he faced the top prosecutor named Pilate. Pilate didn't care one way or another and offered to save Jesus's life, but Jesus refused because backing off would've undermined his message and the world counted on him to tell the truth. So Pilate asked him, What is truth? Was it worth dying for?

I never finished the story because the bully followed us outside and started taunting Chekhov again. Apparently he couldn't leave without trying to punch somebody in the face; his principles demanded that he prove his supremacy over us, or else he'd feel like a failure for the rest of his life. I stepped in front of Chekhov and blew cigarette smoke into the bully's face.

"What are you, his butt buddy?" he shouted. "Look everybody, another faggot!"

"You want a fight, go ahead." I realized he was trying to provoke me but I wanted him to throw the first punch. I slowly raised my cigarette and flicked it at his face, aiming between his eyes. Instead of attacking me

he recoiled, covered his head, and whimpered. My cigarette bounced off his head and fell on the ground.

"Stand still!" an angry commanding voice screamed in my ear, startling me. "What do you think you're doing?"

I turned around and came face to face with the local commandant in the rank of a colonel. The bully must've seen him coming and set me up by pretending to be my victim.

"You think if you're older you can be a jerk?" the colonel's red, porous face loomed, his breath reeking of vodka. For the sake of decency and stylistic integrity, I am withholding profanities that fired out of the colonel's mouth like bullets from an AK-47 automatic rifle. "I have ways to deal with bullies like you. You'll find out what strict military discipline means."

"That's who the real bully is," I pointed at my adversary, who returned an innocent stare.

That made the colonel even angrier. He burst into a monologue which, in polite terms, came down to a demand not to change the subject, as well as a reminder that cigarette stubs on the parade ground were against the rules. And since he couldn't think of anyone else to clean up after me, he proposed that I start picking up every single cigarette from the ground until the entire territory was clean. Should I miss a spot, I'd have to start from the beginning. He would be in his office expecting me to report completion in about one hour. There was no point in arguing.

"How will you know I've picked them all up?" I asked.

"Don't be a smartass," he said. "You'll bring everything to me and show what you've collected. Carry them in your pockets for all I care. Dismissed, all of you!"

The bully smirked victoriously from behind the colonel's back and ran towards the barrack. He soon reemerged, carrying his backpack on the way to join the new "owner." Chekhov followed him with his eyes. "I have an empty plastic bag in the barrack," he told me. "Give me a second, I'll come with you and help."

The profusion of cigarette stubs on the parade ground suggested that a rule against them had come from the colonel's imagination. That was my first lesson in military discipline: rules were subject to change without notice. As we picked up the litter, I gave Chekhov tips on how to avoid future bullying.

"Figure out who the ringleader is and punch him between the eyes as hard as you can with your body mass. Given your weight, chances are it'll knock him out. The others will leave you alone."

"What if they beat me up?" he asked.

"They'll beat you up anyway and worse," I said. "But if you do as I say, they'll avoid you after that."

"I don't know if I can," he said through the tears. "I'm afraid and I don't know why."

The barracks around us were nearly empty. Outside every barrack door stood a bucket with sand in case of a fire, and every bucket was filled with ashes and cigarette stubs, left over by the recently departed draftees. Chekhov proposed that we scoop up those as well, along with the sand and the ashes, to double the volume. Soon our bag resembled a stuffed pillow.

When I was ready to face the commandant, Chekhov tried to cheer me up. "You're still a civilian and haven't been sworn into service," he said. "This guy doesn't own you yet."

"Aren't we all in the service of the state from the day we are born?" I answered rhetorically.

At the appointed time, I stood in the main office clutching a swollen plastic bag that smelled like a thousand ashtrays. The colonel sat at a large desk, trying to focus on the papers in front of him and looking drunker than before. I had already been punished and was hoping that would be the end of it, but the colonel wasn't finished. He noticed me, dropped the papers on his desk, and started to discipline me with another profane tirade about my looks and my civilian clothes. His uniformed assistant giggled. Encouraged by his giggling, the colonel went for a new round of insults about my name and my family.

Had he stopped at the first rant, I might have accepted my defeat and left. Now he was insulting me simply for his own amusement, acting like the bully whom he'd defended earlier. Before I knew what I was doing, I stepped toward his desk and planted the smelly bag squarely on top of his papers.

The colonel's bloodshot eyes bulged in disbelief.

"I'll stuff your mouth with this garbage," he screamed, slurring his speech.

"Just following your orders," I said calmly.

"You'll be swallowing these cigarettes together with your broken teeth!"

"Not before you count them." I flipped the bag upside down and gave it a vigorous shake so that nothing would be left in its folds. A pile of malodorous trash rolled over his desk, with some of it falling into his lap. A suspension of ashes and dust floated over the colonel's papers in brief silence, as he followed my movements with a mesmerized look.

"Are you insane?" he finally shouted, recoiling from the desk and shaking the stubs off his clothes.

"That is correct!" I shouted back. "I'm a psychopath with serious anger issues, aggravated by an antisocial personality disorder!"

It felt as if someone else was raving like a lunatic on autopilot, while I had become detached from my body and simply observed an act in a theater of the absurd, hoping that this better help me get out of the military service, or else.

"I can't wait to get into the army and lay my hands on a real gun with all the ammo I need," I heard myself improvising. "I'll be shooting up bastards like you wherever I see them, and when I'm done there, I'll roll into this compound on a tank, find you cowering under this desk, and empty an entire magazine into your dirty mouth. I think I'll enjoy that very much. And guess what? Nothing will happen to me because I'm certifiably insane. All the blame will be on you for enlisting a psychopath and allowing him access to weapons."

I was leaving no space for retreat, but I didn't care anymore. I didn't want to go back to the way things used to be for me. I kept screaming at the colonel, but my mind pictured others around him: my college dean who blocked me from going to Oxford; Anastasia who wouldn't join me in Siberia; the redhead doctor who left me crippled; physicians who said I couldn't be cured; the bully who'd set me up; Igor who drove his victim to suicide; his father who covered up a latrine with a poster of Lenin instead of fixing it; the saleswoman who refused to sell me art supplies; my art tutor who neglected to teach me art; the village woman who had never eaten a peach; and the girl who once drew me a butterfly.

The colonel's red face turned crimson. "He thinks he's the first pretend psycho in this room," he told his assistant, who nodded in agreement. "I'd like to open his skull and rearrange it myself, but we'll have to let a forensic psychiatrist do it. Too bad."

Then he turned to me. "We could've handled this privately, but now you're going to prison for faking an illness with an intent to avoid the army. I know a con artist when I see one, and I can promise you right now that soon you'll be doing hard labor, like all the other fakers. That's three to seven years in the USSR Criminal Code. I'll find out what prison you're in and then we'll see who'll be firing what in whose mouth."

As the guards escorted me back to the barracks and out of the compound, Chekhov and all the others lined up on the parade ground to wave me goodbye and wish me luck. The words "military camaraderie" came to mind.

17

On a beautiful sunny day in the end of May, I reported to the Department of Forensic Psychiatry, packing a toothbrush and art supplies. Secured by a tall chain-link fence, the Department's two-story brick building housed inmates whose mental fitness needed to be verified before they stood trial for felonies or draft dodging. My new temporary retreat was part of the Tumen mental hospital that served all of West Siberia. It consisted of about a dozen similar buildings in a secluded forested area, away from city noise, calamities, and temptations.

The warden issued me worn pajamas with slippers and took away all my clothes and other belongings.

"Is there a similar facility nearby that examines the mental fitness of women?" I asked.

"There isn't," he grumbled. "Don't ask stupid questions."

"Why is it a stupid question?"

"Because no one has ever asked it. You're the first one."

"I thought it was logical," I said. "If women are charged with crimes, there should be a forensic department to check if these women aren't crazy."

"All women are crazy. Stop asking me stupid questions."

The potentially violent and misbehaving inmates were kept on the first floor with thick iron bars on the windows and a steel-plated entrance. The warden brought me in through a different entrance to the second floor and showed me my bed in a room with seven other inmates. The regimen here was less strict than in prison. Instead of grated security doors, our rooms had wide doorless openings, so the wardens could watch us from the hallway. Our meals contained so few nutrients that we were always hungry. Those who performed physical work on the grounds and otherwise exhibited good behavior earned a coveted reward: a raw egg for breakfast in addition to the watery porridge.

Once a day the warden hollered, "Smokes!" which marked the time when we would receive our cigarettes. They had been confiscated when we arrived and now the warden distributed them through a small window, one pack a day. When we weren't sleeping, eating, or seeing the doctors, we could walk in the enclosed yard or sit in a wide hallway that doubled as a dining room. There we could play chess or watch the black-and-white TV set that hung from the ceiling in a metal frame. To switch channels one needed to climb on a chair, but with only three state-run channels available, hardly anyone bothered to do so.

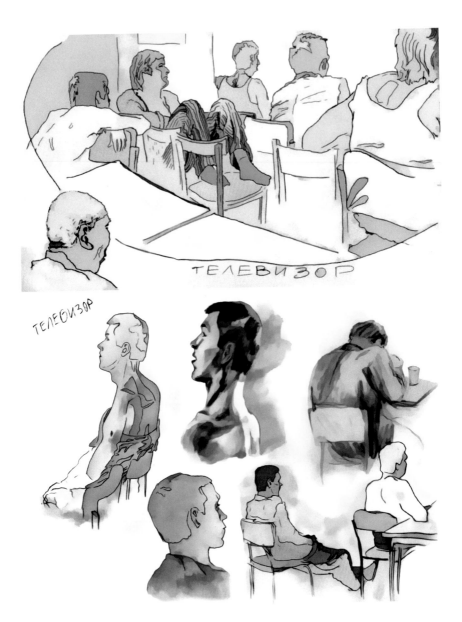

A fellow draftee had a battered acoustic guitar which he let me play. Once the doctors allowed me to have pencils and paper, I began to spend most of my time drawing. Once again, I was among people of many ethnicities whom I may not have met

otherwise. A disproportionately large number of them were from the Caucasus Mountains.

I still laugh at the way the word "Caucasian" is used in America. In the Caucasus proper, a "Caucasian" is a representative of about sixty distinct ethnic groups that inhabit the Caucasus Mountains - from Armenians and Georgians in the south to Chechens and Ossetians in the north. They speak sixty different languages that belong to five unrelated linguistic families. Russia had conquered the Caucasus during multiple wars against Turkey and Persia, and the Soviet Union inherited that ethnic mix from the Russian Empire. Unable to tell all these dark-haired and big-nosed people apart, Russians usually call the whole lot of them "the Caucasians," but the locals can easily tell one another's ethnicity by their facial features. A young Ossetian guy at the hospital immediately identified me as an Armenian, even though I'm only half Armenian and have light blue eyes. I drew a picture about his dream of flying back home on a magic carpet.

Most inmates were tight-lipped about what had brought them to this place, but their occasional comments and bits of chitchat filled me in on important details.

A thirty-year-old Chechen named Ahmed stole a briefcase full of cash, and when the victim found him and demanded it back, Ahmed kindly offered to split the money. The robbed man refused and the indignant Ahmed beat him up for the lack of appreciation of his kindness. The man woke up in the hospital and called the police. Ahmed may have been crazy, but when he and I played chess, he always won. That was my luck because, as I later learned, the last inmate who beat him at chess was punched in the nose.

Ahmed then spent a week in the first-floor prison, but he spent almost half of his time there anyway. He would often get sexually aroused without any outside stimulus and female nurses refused to change his bed, claiming they'd get pregnant just by touching his mattress.

There was also an older man who had killed his wife with an axe, and a young kleptomaniac who came off as completely normal, except that he sometimes stole things for which he had absolutely no use.

A lovable young schizophrenic from a family of alcoholics told me he had two small men living in his head. He said that before they got in, they'd killed a stray cat and made themselves coats out of its skin. They constantly fought and argued with one another as they dug tunnels through his brain. He'd grown tired of hearing them fighting in his head and was hoping the doctors could make it stop. It was also entirely possible he'd made it all up in order to dodge the draft. When the warden brought him into our room and showed him to a bed next to mine, he politely introduced himself, told us about the men in his head, gave us a stack

of humor magazines to read, fell on his bed, and immediately started to snore like a long-haul truck with a punctured muffler.

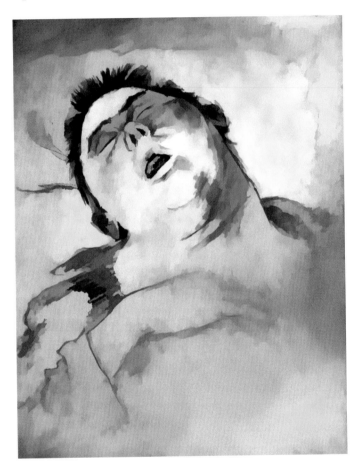

There was a young man from the Caucasus who said he'd committed a crime while in the army, but refused to say what it was. He wanted us to think that he was a gangster, and when I pointed out that he didn't have any gangster tattoos, he grabbed my bottle of black ink and began to tattoo a cross on his leg with my sharp metal pen. A nurse caught him in the act, confiscated the ink and pen, and I was no longer allowed to use them without supervision.

This picture shows him smoking a *papirosa* - a wide cigarette with a long, hollow cardboard tube that serves as a filter and a disposable cigarette holder. The tube can be squeezed into several perpendicular flat surfaces to make it catch more of the tar and prevent the tobacco from getting into your mouth. Everyone smoked *papirosas*, including me. They were strong, cheap, and available in all kiosks.

The consistently sunny weather allowed us to spend much of our time in the courtyard, with me making sketches of the unsuspecting inmates.

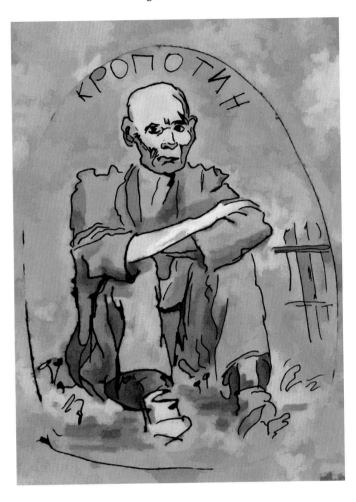

There was an old man who wasn't a felon, but rather a lifetime mental patient. He'd been transferred from another department out of mercy, to stop the beatings he sustained from other patients. He always sat in the yard alone. Once in a while he would pick up a discarded piece of paper or a candy wrapper, quickly put it into his pocket, and return to his post. When I asked him why he did that, he replied with quiet dignity, "I will write my name on this paper and it will become my property." But before he could enter the building, male nurses would stop him and

forcibly empty his pockets. They threw everything into the trash, disregarding his teary appeals about his right to own property. In the end, he owned nothing; even his hospital pajamas and slippers belonged to the state.

This would be his existence until his death. I knew nothing about his previous life and could only make guesses whether or not he once owned anything. It could be a house, a farm, or some other family property, which was taken from him by the state, causing a mental breakdown. Whatever the case, his condition struck me as a metaphor of Soviet life: the state emptied our pockets but provided us with essentials. When all property belonged to the state, people were reduced to the lowest common denominator.

One of my models, a shady guy with a dark pharmaceutical past, offered me a half of a "funny" pill as a sign of friendship. I took it out of boredom and curiosity, and then for several days couldn't control my pencil. My mind helplessly watched as my fingers drew bizarre lines instead of the faces, while at the same time still capturing the character of the model. I was both amused and terrified that I would remain like this forever.

The spell went away in a few days, but I retained the ability to reproduce it on demand. I thought of it as a lesson in breaking down the superficial reality and getting straight to the point with the minimal number of strokes. The strokes didn't need to be factual to reveal the true character. It was just like the letter "D" that resembled my schoolteacher. I had realized that the miracle was in the angles, proportions, and deviation from the expected, but knowing wasn't the same as doing. And here I was, performing miracles at will. No drug could have given me such lasting euphoria as my drawings did.

Drawing in that manner was fun, but doing it forever would have been tiresome. I soon returned to my usual style, appreciative of my newly acquired skills and using them when appropriate.

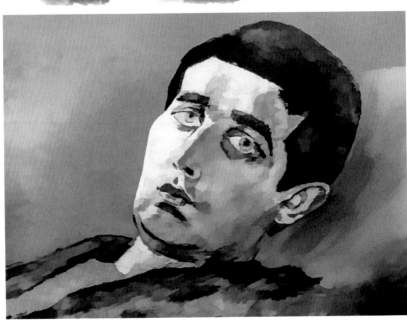

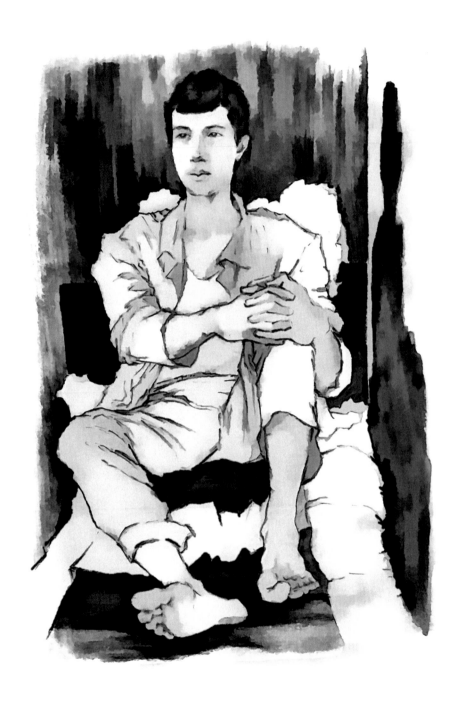

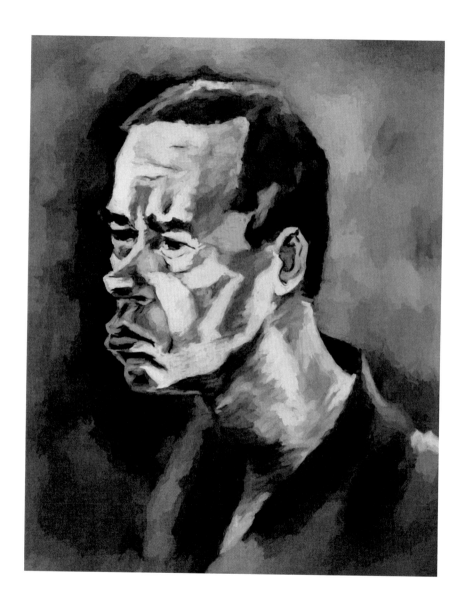

The three doctors at the Forensic Department were young and intelligent. After a few exchanges about art and literature, they began to invite me to their spacious office for a cup of tea and informal conversation. I made their portraits and they all wanted to keep them, along with a few of my wild fantasy drawings. It seemed that during these meetings all parties enjoyed a respite from dealing with the criminally insane.

One corner in their office displayed artwork by previous patients, most of whom were diagnosed schizophrenics. Describing visions too personal for anyone to relate to them, the drawings were meaningless and disturbing. The doctors pointed out that my pictures were different because they made sense and even the most surreal of them were relatable. I said they might change that tune if they saw my billboard of Lenin. As a joke I suggested they run an institution-wide contest among schizophrenics for the best agitation and propaganda poster. For a while we entertained ourselves imagining what the submissions and possible slogans would look like.

I didn't feel like pretending with them and faking an illness. They were professional experts at detecting false agendas and a lie might ruin our new-found friendship. Already during our first meeting I told them I was normally rational, calm, and dependable, but I couldn't stand bullying and injustice, which was what our conscript army was known for. I described my episode with the colonel, saying that it hadn't been planned; something inside me had simply erupted. I wasn't scared of the physical hardships and discomforts of a soldier's life. I was afraid of another eruption: it could get me and others killed.

The doctors said they would consider my predicament and asked me to bring more drawings for the next appointment. They also increased my ration; now I received a raw egg with every breakfast. I hated raw eggs and swallowed them in one gulp to avoid the awful taste, but it was better than going hungry.

Soon I also received permission to leave the area and go to the beach. Of course, I carried my drawing kit with me. A mile-long path to the river stretched through the forest and then through some farmland. The river was cold, but it felt good to be swimming again. In lieu of a swimsuit I wore hospital boxers that screamed "mental institution," and that helped me to pretend that I didn't care as I sat on a piece of cardboard and drew pictures of the beachgoing locals. I represented my alma mater well.

166

I made friends with a nurse named Olga. She was twelve years older but it felt like we were equals. I let her read my journal with my thoughts, poems, and unfinished short stories. She said that of all the men she had met, I was the brightest. The doctors were very bright, too, but they were all married. Too bad she wasn't born twelve years later, she said. I drew her portrait, adding a military hat that made her look like a WWII nurse. It was a joke but she didn't laugh.

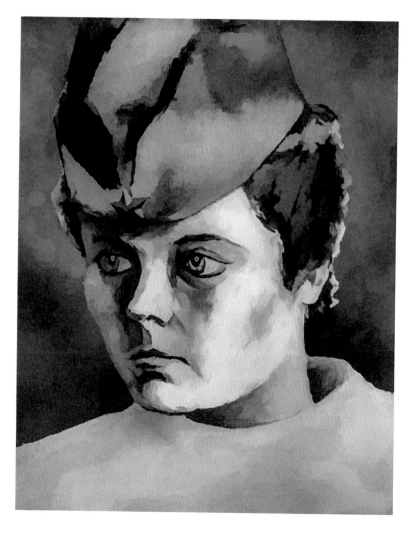

I will always remember my time at the Department of Forensic Psychiatry as the most peaceful, happy, and productive period of my life. But all good things come to an end, and there finally came time for the forensic diagnosis, ending my two months as an inmate. The doctors' verdict would determine whether I'd be relieved from service and go home, or spend years in prison at the mercy of that vindictive colonel. To help me go free, the doctors needed to find a legitimate medical reason for doing so.

Finally, one of them suggested a painless but risky procedure of lumbar puncture. I agreed to it, he punctured my spine with a syringe, and discovered elevated spinal fluid pressure. That was the culprit responsible for my short fuse, which put my survival at risk. It became my get-out-of-jail-free card.

I would now have to take the doctors' conclusion to my local military commissariat, where I'd be issued a military card. All Soviet citizens of male gender had passport-sized military cards, listing their training, service, and fitness for duty. Mine would have a disability record.

The doctors had mentioned it would preclude me from having a driver's license, but that was the least of my worries. I couldn't imagine myself owning a car and didn't expect I could ever afford one. Even if I could, I wouldn't want it because Soviet cars broke easily and repair shops didn't exist. I knew car owners who by necessity had learned to be their own car mechanics, always fixing something, rebuilding engines, looking for spare parts, or manufacturing parts out of junk. The elites were spared that fate, but I didn't expect to become one of those, either.

I was more concerned about living the rest of my life not really knowing if I was right in the head. For obvious reasons, the doctors couldn't explicitly tell me whether my disability was real. Was I indeed damaged goods?

18

Olga stopped me in the courtyard to say good-bye. She looked nervous. She had a proposal for me, she whispered. We headed to a secluded bench in the corner. Pressing her fists together, she told me in a hushed voice that she'd given up looking for a decent, non-drinking man for a husband. Her childbearing years would soon be over but she desperately wanted to have a baby. She'd decided to get pregnant and raise a child on her own. Of all the potential fathers she knew, she thought I was by far the most talented, intelligent, and good-looking. With all those qualities in one package it would be the best baby she could wish for. She paused. Then, focusing her gaze on the clouds beyond the security fence, she asked if I'd be willing to impregnate her. She said she'd just begun ovulating, and since my train home was leaving the following afternoon, it would be good to do it tomorrow morning, while I was still in town.

Having spent two years in Siberia without a woman's touch, I was in no condition to resist.

Olga lived with her mother, so spending that night at her place was out of the question. A hotel wasn't an option either: they wouldn't let her in with a local propiska, and if she tried to sneak in and get caught, this could end up in a police report.

We agreed that Olga would take a day off, wait for her mother to go to work, and meet me at a downtown bus stop at ten in the morning. Then we would take a bus to her place. She had no telephone; in case of an emergency, she gave me the office number of her best friend Tamara who worked in a library.

I made sleepover arrangements in the city with a friend. His parents had recently died, leaving him alone in a one-room apartment in a downtown housing project. We had met at the hospital and I made quite a few portraits of him. He was smart, funny, played the guitar, and didn't seem like a psychiatric patient. He'd been discharged a week earlier with a disability in his military record. I had assumed he was merely a draft dodger, but once I stepped inside his apartment I realized that he was truly crazy. The place was filthy and crawling with thousands of bedbugs whom he didn't even try to kill; I soon realized that he treated them as his pets. His single room had only one bed, one table, and one armchair. It was getting dark; I knew no one else in that city and grudgingly opted to stay. My plan was to leave early in the morning, have a big breakfast in a café across the street, meet up with Olga at ten, and take the train home in the afternoon.

I brought a few beers and we drank them in his kitchen. I didn't see any food. Assuming there was dinner in the fridge, I opened the door and looked inside. It was empty. When I closed the refrigerator door, my friend stood in front of me naked. He said he was going to take a bath and invited me to join him. I laughed it off. This was something new; during our stay at the hospital he never gave any sign he was attracted to men. After a few more unsuccessful suggestions to have sex, he went to bed. I stayed awake in his grubby armchair, hungry, and brushing

off bedbugs every few minutes. I was thinking about Olga. No doubt, she saw my medical file and spoke to the doctors. She wouldn't have offered to have my baby if she believed I was sick. Her proposal was proof that I wasn't damaged goods. The thought cheered me up. I fell asleep by five in the morning.

"Didn't you have to be somewhere early?" My friend was shaking my shoulder. I looked at my watch and screamed. It was eleven o'clock.

I ran to the bus stop but Olga wasn't there. I found a payphone and dialed the library asking for Tamara.

"Tamara has left for the day," a woman answered.

"I'm looking for her friend Olga," I said, trying to sound calm.

"Olga was here fifteen minutes ago," the woman said. "She was in tears and furious."

"Did she say anything?" I asked, my heart sinking.

"Only that she'd been a fool, waiting at a bus stop for an hour. Tamara took her out for a drink. We don't expect them back, try calling tomorrow."

"My train leaves in a few hours," I said.

I spent the rest of the day at the railroad station, calling the library every hour to no avail. I never saw Olga again.

On the long ride home I kept thinking about the responsibility of being a parent. Would it have been a boy or a girl? I would have never known. I could only imagine the heartache of knowing that I had a child growing up far away from me, with a single mother and very little money, and without a chance of ever seeing him or her. On the other hand, if everyone thought of heartache ahead of time, there'd be very few children in this world. I would've had no childhood friend raised by a single mother. Would he

have preferred not to be born? I doubted that. For the first time in my life, I realized how good it would be to raise my own children in a big, loving family. Though I might be a failure in everything else, I could teach my kids well and hope they'd be luckier than their father.

19

By the end of July I was back at work. My two-month absence had gone largely unnoticed. Mikhail Gorbachev had recently announced Perestroika and Glasnost, and propaganda officials had a hard time figuring out how to translate that into visual agitation. My boss's catalog had nothing on Perestroika. I remembered my joke about an agitprop contest in an insane asylum and came up with a few new ideas. One would be a large portrait of Karl Marx with the caption:

WORKERS OF THE WORLD, NEVER MIND!

Others would have no images, just the hammer and sickle at the top and golden letters below:

WE ARE SORRY
FOR THIS FALSE APOLOGY

THIS NEW AGITPROP
REPLACES ALL PREVIOUS AGITPROP

THIS POSTER IS LEFT INTENTIONALLY BLANK.
WE HAVE NOTHING TO SAY TO YOU.

I didn't share these ideas with my boss. He had no sense of self-irony. If he had, he wouldn't have been a Party Organizer. His job came with great perks, though; he was using them while he could, preparing to take all his family on a free month-long vacation at a Black Sea resort, courtesy of the workers' unions.

I entertained myself imagining what he might say upon his return, if he were to find out that I'd plastered our part of town with these wacky posters. Then I imagined what propaganda officials in Moscow might say if someone were to add truth serum to their vodka, and insane poster ideas started popping up in my head one after another.

LONG LIVE FEUDALISM

OUR GOAL IS OBEDIENCE

TRUST US, WE ARE LIARS

LET'S STRUGGLE TO PRETEND WE'VE SUCCEEDED

VOLUNTEER COMPLIANCE IS MANDATORY

CURRENT TRUTH IS SUBJECT TO CHANGE WITHOUT NOTICE

In the first week of August I requested a vacation, collected my pictures, and went back to Ukraine.

My old house was still the same, and so was the city. Everything seemed just as frozen in time as I remembered it growing up. Only the large five-star Brezhnev portrait had been removed from the post office on Lenin Square, and people could once again see the clock hidden behind it. But the Lenin statue remained, and so were the rusty "Our goal is communism" letters on top of the hotel. I didn't want to look for Anastasia, and I imagined she wouldn't be happy to see me either.

What struck me was how much greener Ukraine looked compared to my new Siberian home. It had so many trees with such big leaves! The extreme disparity of unregulated nature seemed almost obscene. If only this foliage could be equally redistributed, I thought in tune with my insane agitprop slogans. How could the state allow this abundance when others had little? Why hadn't the Party done anything to correct this inequity? My collection of crazy slogans kept growing:

DOWN WITH THE LEAFAGE GAP!

FAIR QUOTAS ON VEGETATION NOW!

REGULATE NATURE!

I went to see my friend Yan in his new art studio, which he'd recently transformed from an old shed. We drank beer, looked at his new paintings, and caught up. He suggested that I try joining an upcoming exhibition of young local painters at the House of Artists gallery. A certificate from an exhibition and maybe a mention in the press would go a long way towards Artists Union membership. I

agreed and he helped me to set up a meeting with the head of the exhibition committee.

I showed up for the meeting carrying a folder of what I thought were my best works. The committee chairman, a soft-spoken middle-aged man, politely let me know that he wasn't impressed. My drawings were often done with hard pencil on low-quality paper more suited for wrapping fish. I had to agree that it made many drawings look unprofessional, and the fact that the Cultural Goods stores in Siberia didn't sell better paper was an unacceptable excuse.

Watercolors were next. I had to explain that I was using inferior paints made for children because professional art supplies were unavailable. He empathized with me, but there was no way to explain this to the patrons. Once again, I had to agree that people at the exhibition would expect real art instead of someone's inferior work with a note attached, explaining how this artist had no access to art supplies.

Next were the oils. That's where I'd made the biggest investment, bartering vodka for professional paints, brushes, and thinners. But I'd made some mistakes. Instead of canvas I used pieces of pressboard, painting on the softer back side because of its canvas-like pattern, but that side hadn't been coated with a sealant. Instead of a primer I used common emulsion wall paint, which wasn't a sealant at all, and that allowed some of the pigments to seep into the pressboard. With time, most of my paintings lost vibrance and saturation. I'd been noticing changes in the original colors, but I wasn't sure why. The committee chairman confirmed my suspicion.

"Of course you should've used the professional canvas primer," he said. "I'm really sorry, but none of it is exhibition material. I'm not saying that you should quit, of course. By all means, continue painting and drawing if it gives you joy. Art is such a wonderful hobby."

"The worst hobby one can have in our planned economy," I said.

"Well, maybe you should've tried going to art school."

"Maybe my mom should've found me a better art tutor," I mumbled, throwing my drawings back into the folder.

"Maybe if you had a more caring family," he shrugged.

"Maybe if I lived in different country," I said. "But thank you for your time."

I didn't want to look at my pictures again and stuffed them into my bedroom closet. Then I returned to Siberia and worked there for another year, trying to save up money for my future family. The next time I tried to paint, it didn't bring me any joy. If all of my previous art was damaged goods, what was the point in creating more? Feeling resentful, I painted less and less frequently, until one day I just stopped. The decision to quit brought me relief. I also stopped thinking of myself as an artist and introducing myself as one. At one point I came to work, unlocked my shop, and wondered what I was doing there, inhaling all that paint. How did I end up with this weird job, making posters that never made sense to me, and now they didn't even make sense to my boss? It was time to move on.

I met a woman who was a single mother and we got married in the same Siberian oil town that was once meant to be only a brief stop on my way to the army so I could marry Anastasia. A state official stamped our passports on page eleven and, in perfect calligraphic handwriting, listed the date, the place, and my spouse's full name. It wasn't Anastasia.

20

Towards the summer, the news arrived that our old house in Ukraine was finally scheduled for demolition to clear space for a new high-rise. By law the city had to provide all the residents with new apartments according to the size of their families. That required my physical presence, especially that I had left as one person, and now I was married with two children. The bureaucrats looked not at the people but at their passports, to verify that their alleged residence matched the *propiska* on page 16, and that all their alleged children were listed on page 13. I would've been out of luck but the special status of a Siberian worker helped to restore the *propiska* in my Ukrainian hometown.

I moved my new family to my childhood home and we lived there for a few months until we got keys to a new apartment. It had two bedrooms for four people - very generous by Soviet standards. With my younger sister as the only remaining child, my parents received a one-bedroom. Our new home was not far from downtown, in a recently built nine-story housing project made of light-gray concrete panels.

As I carried my belongings from the old house, I carefully detached the paper with my teenage wall

drawing and rolled it up. Then I shoved it along with my other artwork into the new closet and out of my mind.

My degree in English and German helped me to find a job as a technical translator at a research institute. My monthly salary of 115 rubles was just enough to provide my family with state-subsidized food, but in real world prices it was worth less than a pair of blue jeans on the black market. Luckily, we could dip into my Siberian savings.

I was now spending more time writing short stories. The only supplies I needed for that were a ballpoint pen and a notebook. On my lunch breaks, I used one of the office typewriters to type up clean copies and submitted them to several magazines. Not holding my hopes up too high spared me the disappointment of rejections. I knew that my stories were good because their copies had already been circulating among my friends, their friends, and their friends' friends. Sometimes they submitted my stories for me, getting them published in rebellious new periodicals based in Latvia and Estonia. Years later I discovered one of them translated into Bulgarian for a collection of short stories. Five of them became compiled into a Moscow-based young writers' almanac.

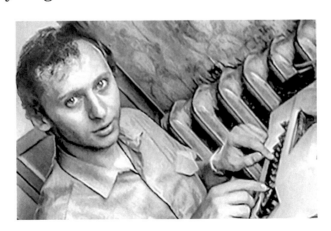

Some people described them as satirical parables. Like some of my drawings, they cracked reality in order to get to the point with the least amount of strokes, which made them both humorous and disturbing. For example:

GIFTS OF THE STATE

Once upon a time, on the eve of the Big State Holiday, I came to a State Store looking for salt. I found packets of salt in the crates on the floor, but then some man told me that the State had already purchased this salt and that I had to go home. I still grabbed one packet, but he tore it out of my hand along with my fingers, and tossed it back into the crate.

I went home under the falling snow. Just as I began to admire the snowflakes, I was approached by a man who said that the snow belonged to the State and he removed my eye.

I paused by a public loudspeaker to listen to the music, but a man came over to me saying that music belonged to the State and he cut off my ear.

I ran to the pharmacy. The pharmacists told me that my organism belonged to the State and I was taken to the State hospital. At the hospital they cut out my stomach, my liver, and my lungs, because all nutrition and the breathable air also belonged to the State.

The hospital issued me an official paper stamped with the State seal. I brought it to work, where everyone was getting ready for the Big State Holiday, receiving gifts from the State.

I too, received a gift box. In it I found a packet of salt with my severed fingers, my eye, ear, stomach, liver, and lungs. All were held together with a red festive ribbon and accompanied by cordial holiday greetings. Overjoyed, I joined others in singing a holiday jingle about how happy our life was when the State provided us with free vital necessities. And that's when the Big State Holiday started.

My boss at work was a vigilant Party member. She always checked what I typed to make sure that I wasn't engaging in sedition. A single and still attractive woman in her fifties, she could be mistaken for Kathleen Turner in Romancing the Stone if it weren't for her old woman's clothes and a vintage hair bun that looked like a loaf of braided Easter bread glued to the top of her head. The contents of her head were just as dated.

One day in the summer of 1987, I was passing by a downtown Cultural Goods store and noticed a portable typewriter sitting in the window. I'd never seen one for sale before. On the following day during lunch break I ran to the store and bought it with my Siberian cash. When I returned to the office with it, my boss became alarmed.

"Is that a typewriter?" she raised her eyebrows.

"Just bought it at Cultural Goods." I opened the carrying case, showing off my new mechanical toy to the coworkers.

"Well, do you have an authorization to own a typewriter?" she inquired.

"I didn't know I needed an authorization," I said, somewhat puzzled.

"So you're saying that now anyone can simply walk into a store and buy a personal typewriter without as little as a background check?" she insisted. "I find it that hard to believe."

"Is that how it was for your generation in the old days?" I said. "That I can believe."

"I'm not that old," her face turned red.

"I know you're not, you're just more experienced. No offense."

"In my experience I've seen typewriters being used to print dangerous materials. This is why they ought to have license and registration as if they were guns.

A lecturer from the Knowledge Society once told us that every typewriter has a unique imprint, and as long as it's registered, the KGB can trace every typed page back to a particular machine."

"Just like a movie detective can trace a bullet back to the murder weapon," I said. "Makes sense."

"All I'm saying is that if you have an unregistered typewriter there may be consequences. As the head of this department, I am personally responsible for every sheet of paper typed up in our office. For years I've been making sure that nothing questionable can be traced back to us. What good is my vigilance now if anyone can own a personal typewriter?"

Her flushed face was nearly in tears from a realization that years of her sacrificial service to the Party could become meaningless. It was as though she was falling through the air and all she could think about was how much effort she'd put into ironing and folding a parachute that now wouldn't open. Of course, this conversation was only a symptom of larger societal change that threatened to erase everything she lived for. Her faith in the Party was still solid, but the pillars on which it stood were crumbling. How long before her faith would come crashing down? Many communists were going through a similar existential crisis.

My boss stayed late in the office that Friday night. No doubt, she used her state-owned typewriter to inform the proper authorities that I was in possession of a privately owned typewriter, and to warn them about my politically unreliable tendencies. To her generation this was a big deal. To mine it was a big joke.

Monday morning she picked up where we left off. "I made inquires over the weekend and you were

right," she admitted. "You may go ahead and use your typewriter at home."

"Thank you for your kind permission," I said. "Long live the freedom of speech."

"But as a Party member, and I'm not afraid to say this, I think our leadership is making a huge mistake."

"See? You're no longer afraid of consequences when you criticize our leaders. At this pace your Party will soon go the way of dodo, Brezhnev, Andropov, and what was the last dead guy's name, Chernenko?"

"You realize that a few years ago you could be arrested for talking like this?" she inquired sternly.

"Would you like to see me arrested?"

"No one likes to see people arrested, but I wish you wouldn't say these things out loud."

"What's the point in having free speech if we can't say what we think?"

"And what will happen if everybody starts saying what they think? Total chaos."

"It's better than thinking one thing but saying another," I said. "People are tired of hearing things they don't believe are true."

"How can they tell what's true? What is truth, currently?"

"The current truth is that everything is a lie, including this current truth. Subject to change without notice."

"Very funny," she said. "But how can one live when everything is a lie?"

I stopped myself from telling my boss that she should know that better than me. "Maybe we should focus less on the current truth and rely on something more permanent, that won't change tomorrow or next year," I said. "Something that

doesn't criminalize human nature, so we don't have to lie about it."

"And what is that?"

"It's what we weren't allowed to say and what could get us arrested a few years ago. And now it's making the front pages of leading newspapers."

"Those newspapers are digging dirt in our country's past, trying to discredit our history and everything we are proud of," she scoffed. "What good is the news if it comes from the past?"

"I like it," I said. "I'm curious to find out how much of what we learned in school wasn't true. Aren't you? We believed in many things because we've been lied to, and now the truth is coming out. If that happens and people don't reassess their values, they just aren't taking their mental health seriously."

"I'll stick with what I know, may I?" she said coldly.

"You may," I agreed. "That's what freedom means; I can't tell you what to think. No one has the monopoly on knowledge anymore, even the Knowledge Society."

She looked scared.

My friend, the son of Party officials, had opened a private kiosk and did well selling cassette tapes with pirated Western records. I bought a few of his tapes but wasn't impressed with the new music styles; they didn't sound rebellious and innovative enough. He informed me in a hushed voice through the kiosk window that he knew for certain from inside sources that Perestroika would soon be over. The Party and the KGB were about to regain control and arrest all the political loudmouths and private entrepreneurs, and all their private fortunes would go back to the

state. He believed he'd be spared, but he worried about me and wished I'd be more careful with my words, especially with what I write.

I knew that his sources were his parents and he sincerely wished me well, but I didn't believe such a thing would happen. Too many people like me would be willing to go out and fight it, and the fear of a massive uprising made a political reversal unlikely. We just needed to stay on message and keep pushing. In the worst case scenario, I'd be sharing prison with the best people this country had.

My boss's fears proved to be well-founded. A few months after our confrontation, my friends and I started using my typewriter to print our city's first dissident newsletter. Most of it happened in my kitchen. The five of us wrote articles by hand and then typed them with carbon paper, four pages at a time. It was how we also created a petition in defense of a well-known dissident, Andrei Sakharov, hoping to gather thousands of signatures.

When it came to going out and talking to people on the street, my friends chickened out and I ended up standing on the corner and collecting the signatures by myself. During those days, various KGB and Communist Party types swarmed around me like the mosquitoes in a Siberian swamp, harassing and scaring away the signees. They wished they could just have me arrested like in the old days, but they no longer had that power. Instead, they screamed in my face about consequences for me and everyone who would sign my paper.

Fear of consequences had been coded into all Soviet brains like the sound of a buzzer in Pavlovian dogs: one push of that button used to make big men

whimper and scatter in panic. It still worked on some people who had much to lose, but I wasn't afraid. With morbid curiosity, I observed them trying to push my buttons and to find one that would work.

When they threatened me with Siberia, I laughed. When they promised to have my head examined by a forensic psychiatrist, I said I might enjoy that again. When they called me "damaged goods," I replied that I'd always been damaged goods and would remain damaged goods as long as they were in power, so I had nothing to lose. "But I have a world to win," I added, quoting Karl Marx.

21

The seven thousand rubles I had brought from Siberia kept my family afloat until the hyperinflation of the early 1990s wiped out our savings along with everyone else's. I was already the father of three. My family managed through the hard times because I was now receiving my pay in dollars. I'd become a freelance guide and interpreter, working with American visitors who looked for business opportunities in the collapsing USSR. I shared their expectations and hoped Ukraine would soon be a prosperous European nation.

Communist hardliners attempted a coup in 1991 but gave up after four days of massive pro-freedom protests. A centralized state meant that anything important could only happen in Moscow, and Muscovites stepped in front of the tanks, preferring to die rather than return to the old ways. Soon after that, the Communist Party was dissolved. A few

months later, a state called the USSR ceased to exist. We called it the Motherland; it would be Neverland to my children. They would grow up to be free.

So far the biggest victim of the Communist Party's demise seemed to be the Artists Union, whose members lost their prime paying customer. Sob stories began to circulate around the world about the scores of former Soviet artists with skills in realistic classical painting who had nowhere to sell their work.

Their pleas fell on responsive ears. A French art dealer showed up in our city with pockets full of cash and a business proposition. He toured the penthouse studios of the House of Artists with his interpreter, showing prints of Dutch masters and asking if our distinguished professionals would be willing to paint exact copies, as many as they could, for fifty dollars apiece. At that point fifty dollars could sustain a family for a month.

Most Artists Union members thought the Frenchman was a crook trying to use them in a forgery scheme, but money didn't smell, whether it came from communist apparatchiks or capitalist pigs. The dealer had come from the dark Western world whose workings they could never hope to understand; they wouldn't care if his scheme brought down the entire capitalist system.

The artists merrily got to work painting the copies, but they couldn't keep their mouths shut and the word got out. Before any money exchanged hands, someone broke into the Frenchman's room, knocked him out with an iron pipe, and took all his cash. The art dealer flew home on a stretcher and the artists

remained with no money and useless copies of Vermeer and Rembrandt on their hands.

Later that year, a couple of business people from California asked me to arrange a meeting with local artists. The following day, the Artists Union members waited by the doors to their penthouse studios, welcoming the rich Americans. The Americans liked their work but were puzzled that everyone offered them old Dutch paintings at fifty dollars apiece. They were interested in original work, they said. One of the artists protested, saying that those Westerners had better make up their minds whether they liked copies or originals before coming here and messing with everyone's heads.

Trying to beat his competitors, one award-winning artist took me aside and offered to paint my portrait if I would put a good word for his work with the guests. I wondered whose portraits he painted to win all those state awards he'd been bragging about. The Americans bought a couple of his architectural landscapes without any interference on my part.

My old art tutor, too, invited us to his studio. I felt awkward, but he didn't recognize me after twenty years. Looking around the room I saw that he still recycled the same old portraits of award-winning milkmaids and tractor mechanics. Only this time, instead of the Red Army heroes, he painted their faces on medieval Kievan princes and Cossack horsemen, complying with the latest trend of restoring historical heritage. This maestro of socialist realism understood national independence as a command to quit glamorizing Soviet heroes and start glamorizing Ukrainian heroes. He, too, offered to sell a copy of Rembrandt for fifty dollars. The visitors weren't interested in his work.

Once we stepped outside, they asked me to explain what socialist realism was. I said it was basically wishful thinking by means of depicting improbable characters in far-fetched situations, which was also the definition of pornography. They could relate, they snickered, as they'd been intimately familiar with that creative method since they were teens.

Like me, my American clients expected miraculous opportunities on the ruins of our socialist utopia, but none of their business ideas worked. The corruption in government offices was out of control. The murky waters of the old distributive system had taught people survival skills that were at odds with conducting transparent business. All my customers returned to America and I remained, still unsure what to do with my life.

I didn't want my children to grow up in that swampy water. I loved my country and wished it well, but I had no more illusions. I was done with trying to fix damaged goods. Ten years prior to this, Anastasia and I should've moved to America, except we weren't allowed to leave. Now leaving was easy but getting into America had become a problem. The U.S. embassy in Kiev was rejecting many visa applications to prevent a massive economic migration.

22

One of my former American clients agreed to send me an invitation with a promise to cover my potential bills, and that got me a visa. I used my reserve of hard currency to buy a plane ticket and arrived in New York with forty dollars in my pocket. After a few weeks

of living on a friend's couch and standing on the corner waiting to be picked up by contractors, I found a job as a translator and a cheap rental in a rundown Brooklyn neighborhood.

Soon I cured my previously incurable stomach. A private American doctor gave me his full attention, ran a few tests with his futuristic-looking equipment, found ulcer-causing bacteria, prescribed specialized antibiotic, and I bought it the same day at a Rite-Aid pharmacy.

I wound up paying a lot of money, but that single bottle of expensive white pills did what a mountain of free brown pills couldn't do in broken-down free hospitals that could've killed me had I not escaped that trap. And since the American government didn't pilfer my wages in exchange for free services, within a year I had saved enough money to rent a better apartment, buy a used car, and bring my family over so that they could also start a new life. The DMV clerk in Brooklyn who issued me a driver's license didn't request my Soviet military card to ascertain that I was allowed to drive a motor vehicle.

A few months before my departure, my friend Yan had moved to Sweden. Now he was calling me in New York from Stockholm. One time he sent me an oversized envelope that contained a color brochure with his new paintings and a large signed print. The brochure and the print were published by Sotheby's. On the opposite side of the print was a long letter from Yan. He thanked me for helping him to stay free on the inside through the difficult years. He wrote that I'd helped him to discover his own artistic style, which was similar to abstract expressionism but more cheerful, in a Ukrainian sort of way. In the end, he asked me to find out if New York art galleries would be interested in his work: he would love to visit America.

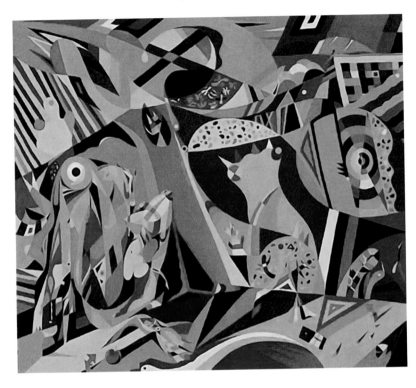

I took his brochure to the trendiest galleries in SoHo, which, according to the New York Times, were the best places to see modern art.

"Not interested," the gallery manager said after flipping through a couple of pages. "Too old-fashioned."

"What's in fashion today?" I wondered.

"Look around," he motioned at large canvases on his walls. "This is today's art."

Had he not told me it was art, I would've never guessed. What I saw were large, good quality white canvases, ruined by random ugly stains that were as meaningless and unrelatable as the works by Siberian schizophrenics. I wished I had as much canvas back home; just one of those oversized frames could easily fit six of my landscapes. The opposite wall exhibited large grimy paintings that

looked like New York subway walls tagged with graffiti by juvenile delinquents. I noticed the hammer and sickle in one of them and couldn't help laughing, remembering my insane propaganda poster ideas. Was the author in possession of a state-issued diploma? The gallery manager heard my chuckle and turned his head.

"In the actual land of hammers and sickles this wouldn't have passed the Artists Union committee," I told him. "But it could win the agitprop contest in a Soviet mental hospital."

"We're pushing the boundaries," the manager argued. "In this country we have to fight for freedom of expression against the bourgeois establishment."

"Well, comrade, you're pushing in the opposite direction," I said on my way out.

None of the other places I visited that day took interest in Yan's work. All their art was depressingly ugly with occasional leftist flair. Yan never got to see America. In July of 2013 he died in Stockholm of heart failure.

I didn't understand many things about America then. I saw contradictions but couldn't explain them and eventually decided that I wasn't smart enough to figure them out. I was more concerned with supporting my family and raising our children. Years later, when I discovered the source of America's contradictions, I wrote and published my first book. Until then, being a free man in a free country was more than good enough for me, and I believed that freedom wasn't an illusion this time.

I was here to enjoy life, liberty, and the pursuit of happiness. Such phrasing seemed awkward at first. Life and liberty were a given, but happiness sounded silly. What kind of an amateur would turn the

pursuit of a fleeting emotion into a cornerstone of the most powerful nation in history? I had been taught that conscientious adults needed to sacrifice for the happiness of society, and ultimately of humanity. On that scale the pursuit of personal happiness looked selfish and small, even embarrassing. When Karl Marx was asked about his idea of happiness, he answered, "Struggle." Thinking about it, I realized that happiness was the goal of Marxism as well, only Marxists struggled for collective happiness.

And yet my old country had never been happy, despite all the struggle and sacrifice for a happier world. We weren't supposed to care about ourselves when the society was unhappy, and it remained unhappy as long as we didn't care about ourselves. With everyone pursuing collective happiness while sacrificing their own, no one ended up happy. So who was being silly now?

The answer was hidden in plain sight: the pursuit of happiness cannot be delegated. No one can pursue your happiness for you. No state has that power. All people have different needs and desires, and even those keep changing. No benevolent bureaucrat can possibly know what makes you happy when even you don't know it half of the time.

Like the talking and feeling animals in children's cartoons, society has been anthropomorphized, as if it is a person who can think with one mind and talk with one tongue. Those who believe in talking animals have become vegans, and those who believe in a thinking and feeling society have become fighters for societal happiness. Some people break up the society into communities and struggle for communal happiness. But society isn't a person, and neither is a community; it can't pursue or feel

anything. There is no collective brain with a public dopamine center that channels happiness to its members. Society is an abstraction, a word to describe all of us - and we all want to be happy in our own ways.

Even then happiness is a fleeting condition; we can't be all equally happy at all times. A picture of societal happiness would be a map of flickering lights, always changing and never the same, brighter one moment and darker the next. As long as there's more light than darkness, a society can be called happy. Each one of us is a small source of light. If we neglect our own lights in pursuit of collective brightness, our map would be as dark as a satellite image of North Korea at night. Their individual lights have been extinguished for the sake of collective happiness, and it brought them a total darkness. The best way to contribute to the overall happiness is to shine your own light and allow your neighbors to shine theirs.

Once I knew that the pursuit of happiness was the essence of human nature, I realized that I'd been instinctively longing for it this entire time, against the rules of the perverse collectivist world I lived in. The only time a twinkle of happiness appeared on that dark map was when somebody broke the sadistic rules of self-sacrifice. The happier people were, the more rules were being broken, the more the tyranny cracked. And then one day it collapsed.

We've all heard the stories of how newly arrived Soviet immigrants would burst out crying on their first visit to an American supermarket. Those weren't the happy tears at the sight of abundance, but rather the tears of anguish at the discovery that everything they'd been taught about the world was a

lie, that pain was not the norm of existence, and their sacrifice for the bright future turned out to be a cruel joke played on them by sadistic despots. All the shortages, waiting in lines, the bribes and kickbacks, the art of getting through the back door - none of it had been necessary. The rat race to obtain essentials, which had been their way of life for several generations - it wasn't normal. Abundance was possible without the five-year plans, quotas, rationing, propaganda, one-party rule, and fear of the all-powerful state.

I know that feeling of shock because I had the same experience, although not in the supermarket.

Walking around Manhattan, I once stumbled across a gigantic art supplies store on Canal Street. The sign said, "Pearl Paint: World's largest art and graphic discount center." I walked in with a sinking heart. Rows upon rows of shelves brimmed with products that catered to every artistic need. No gatekeeper was checking permissions, and no Artists Union card was required to make a purchase. I roamed through the aisles, recognizing a few familiar things and wondering about the purpose of tools and materials I hadn't encountered before. This might as well be an alien planet. I saw younger shoppers picking up those mysterious objects and dropping them into their baskets and carts; they obviously knew how to use them. After the first floor I went to the second, and then to the third. And then I imagined how different my life could have been and broke down in tears.

EPILOGUE

I never painted by hand again. However, my coming to America coincided with the emergence of computer graphics, which was a love at first sight. A few years later, I established myself as a digital graphic artist and web designer.

In the summer of 2016 I visited Ukraine after a 22-year absence. My elderly parents now lived in my old two-bedroom apartment, in the same concrete high-rise. Its once off-white walls were now dark gray and spotted with age. The burnt-out mailboxes in the hallway looked scary. My parents' mailbox door had been ripped out. My mother said she didn't care. Her traditional daily trips to the mailbox were over. Instead of newspaper subscriptions they read news on their Samsung Galaxy tablet and used Skype instead of letters and postcards. With everyone having a cell phone, landlines stopped being a privilege.

My portable typewriter still stood on the shelf where I'd left it. I opened the dusty plastic case and touched a few buttons. Then I closed it and plugged in my American laptop using a European adapter.

After a dinner with my parents I went for a walk, anxious to see all my childhood landmarks. Where my old house once stood was a playground in the back of a residential high-rise. The old pear tree that grew beside it was gone, too. The rest of the neighborhood hadn't changed much. I started to notice changes on my walk towards downtown. I saw new, well-designed

buildings with cozy restaurants and open-air cafes where friendly young people were serving the food. I saw cheerful private shops with imaginative signs, boasting variety and abundance, and the women at their counters weren't the faceless automatons of the Soviet era; they chatted with customers and showed plenty of personality. This was my vision from years ago when I'd squint my eyes and imagine what my city might look without communists. It was finally on its way to becoming a part of Europe.

This improvement happened without any propaganda posters calling on citizens to struggle for the betterment of their lives. There hadn't been any Party directives nor centrally assigned quotas. It occurred by itself when the obsessive caregiver state crumbled and got out of the way of people's natural desire to take care of themselves.

I recalled my tour bus with the broken microphone and the instructions to blame our failures on the Germans whom we had defeated forty years earlier. The current improvements happened in half that time. It hadn't been the old war with the Germans that had been holding us back. Rather, it had been a prolonged war on human nature waged by our government, which always found ways to blame others for its failures.

People were still struggling, of course. Many housing projects, including my high-rise, had deteriorated. The new national government had let the tenants privatize their state-owned apartments at no cost; that created a housing market with millions of instant property owners. That was the good news. The bad news was that these property owners now had to pay for the upkeep of their buildings, and very few could afford it. Many were

retirees with no savings. The previous government had been keeping their earnings in exchange for free services and the promise of pensions, and the new government was struggling to make good on its predecessor's entitlement programs.

Lenin Square had now been renamed and the granite statue demolished; I'd seen it toppled on YouTube in 2008. A small crowd of communist protesters had gathered with placards and red flags, screaming insults and singing old Soviet songs. The intent was to lift Lenin with a crane, lay him on a dump truck, and move him to a less prominent location. That plan failed when a design flaw in the monument caused Lenin to fall apart and collapse at the first pull, just like the state that he founded.

I remembered becoming a Young Pioneer at the statue's unveiling on Lenin's 100th birthday. Thirty eight years later, Lenin's enormous head crashed on the ground and rolled towards the feet of the flabbergasted protesters.

The House of Artists was still around, and so was the art supplies store next to the gallery. I went inside. It was now a commercial gift shop, selling paintings and crafts by local artists. With more paintings for sale than its walls could hold, framed canvases stood on the floor in several rows, some leaning against the counter. Most of them were landscapes filled with sunshine, clean air, and happiness. Their prices were only a tiny fraction of those for the trash-like paintings in SoHo.

The young saleswoman welcomed me with a smile.

"Is everything here for sale?" I pointed at the art supplies behind the counter.

"Of course it is," she seemed confused.

"Paints, primer, canvases? Everything?" I realized how idiotic that must have sounded.

"If you have the money, sure."

"Even if I don't have an Artists Union card?"

"The only card you'll need is a credit card," she said. "You're asking such strange questions."

"But if non-artists start buying paints, will there be enough left for the union members?"

"You're joking, right?"

"I'm glad you say that. Thirty years ago, I was standing right here in this spot, holding cash and asking to buy a few art supplies. I was told to get lost because I wasn't in the Artists Union."

"Thirty years ago I wasn't even born," she said. "Today money buys everything. Where have you been?"

"America. Just came back to visit."

"Wow!" She beamed. "Do you see many changes?"

"More than you can imagine," I said.

I noticed that her generation's memory went no farther than their early years. Was that a good thing or a bad thing? Did they lack the curiosity about what went before, or did they just not want to know? I could see how not carrying negative baggage made their life more enjoyable and productive, but ignorance of the past also stripped them of their immunity from repeating the old mistakes.

I met with my classmates at an upscale hotel restaurant that looked as if it had been teleported from Las Vegas. Before we ordered, I offered to pay for everyone's dinner. I explained that I was by no means a rich American, but my income in dollars was much higher than local salaries, and some of them probably lived from paycheck to paycheck.

They objected and we finally settled on me covering one-half of the bill and them splitting the rest.

We ate on an outside terrace with a view of the river, sipping cognac, laughing, and catching up. To them I still was "the boy who could draw." Someone recalled my fight with a teacher, when I pulled on her sweater to get back my drawing. They all remembered my declaration that I wanted to be a free artist, since communism meant we were free to do what we wanted, and the teacher had promised that we would all live under communism. I asked if they thought I was crazy. Not at all, they replied. They all rooted for me on the inside.

Back at the apartment I asked my mother about my artwork. A few of my paintings already hung framed on the walls in different rooms and in the kitchen. To find the rest, she said, I had to look in the closet and maybe some cabinets. A thorough half-hour search produced several folders with sketchbooks, loose drawings, and a number of paintings on pieces of pressboard. My teenage wall drawing was there, too, rolled-up in the closet's far corner. Many drawings were smudged and discolored. The oil paintings looked bleak.

I took the entire lot to my room and spent the night shuffling through it. My life flashed before me, with all the people, the places, and the stories behind the pictures. In the morning I cleared my old desk by the window and set up the space where I could take digital photos of my damaged portfolio. Now that I was in possession of a powerful computer with graphic editing software and other decadent capitalist inventions, my old pictures didn't need to be damaged goods. My next project would be to restore them on my computer.

Soon I returned to my new home in Florida and got to work. It took me over a year to process more than two hundred images. I organized them, named them, cleaned them up, cropped, sharpened, and restored the original colors and vibrancy. Sometimes I worked from my memory and sometimes from imagination. Then I built a website with a virtual art gallery, *Atbashian.com*, where I was finally free to do what I wanted and play by my own rules. I was the art council, the union representative, and the judge of the pictures that no one else wanted. It helps me to imagine what a real exhibition of my art might have felt like.

I also uploaded some of it to a worldwide online store, *RedBubble.com*. in case someone who reads this story would like to order a print or two. It doesn't matter what country you're from, "cap" or "soc." There won't be consequences for this transaction, and no KGB officer will be watching what's being sold and in what foreign currency. And who knows - if enough people show interest and purchase them, I might just take that cash to a local art supplies store, buy a starter kit, and begin painting again.

HOTEL USSR

ACKNOWLEDGMENTS

Special thanks to my wife Larissa and my good friends Mark Kempton and Tina Trent for their kind advice, encouragement, and help with editing this book.

THE AUTHOR

Oleg Atbashian is a writer, essayist, satirist, and graphic artist from the former USSR. Born and raised in Ukraine, he grew up believing in Communism and at one time worked as a propaganda artist, creating visual agitation and propaganda for the local Party committee in a Siberian town. He became disillusioned with the corruption and the hypocrisy of the socialist system and emigrated to the United States in 1994. His writings present a view of America and the world through the prism of his Soviet experience. Oleg Atbashian is the author of *Shakedown Socialism*, of which David Horowitz wrote, "I hope everyone reads this book." He is also the creator of a satirical website *ThePeoplesCube.com*, His essays and satires have been translated into many languages and his graphics reproduced in various publications around the world.

ALSO BY OLEG ATBASHIAN

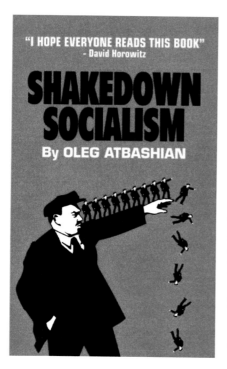

Shakedown Socialism (2010, 2016)

A brilliant study, profusely illustrated with cartoons and propaganda posters, it explains why Socialism cannot work. The book is an eye-opener as the author supports his arguments with examples drawn from his life in the Soviet Union before 1994 and more recent events in the USA.

Available at *Amazon.com*

94410041R00117

Made in the USA
Middletown, DE
19 October 2018